WRITERS AND THEIR WO

ISOBEL ARMSTRONG
General Editor

HAROLD PINTER

HAROLD PINTER

HAROLD PINTER

MARK BATTY

© Copyright 2001 by Mark Batty

First published in 2001 by Northcote House Publishers Ltd, Horndon, Tavistock, Devon, PL19 9NQ, United Kingdom.
Tel: +44 (01822) 810066 Fax: +44 (01822) 810034.

British Library Cataloguing in Publication Data
A catalogue record for this book is available from the British Library

ISBN 0-7463-0940-6

Typeset by PDQ Typesetting, Newcastle-under-Lyme
Printed and bound in the United Kingdom by
The Baskerville Press, Salisbury, Wiltshire, SP1 3UA

Contents

Acknowledgements

I would like to thank the following people for offering their advice, observations and criticisms during the compilation of this book: Frances Babbage, Martin Banham, Margaret and Michael Batty, Lindsay Bell, Richard Boon, Mary Brewer, Christina Dackéus, Lee Dibble, Ben Francombe, Simon Hollingworth, Ewan Jeffrey, Katie Read and Michael Stewart. Thanks to Ewan also for our numerous tea-fuelled chats and, along with Jim and Gaynor, for our modest stab at *Family Voices*. Lauren, too, for *Ashes to Ashes*. I'm grateful to all the friends, colleagues and students who, over the years, have shared their enthusiasms with me and helped to expose me, as actor, spectator or thinker, to the variety of Pinter's works. In this respect, Alex Baldacci deserves a mention. I would especially like to extend my gratitude to Harold Pinter and Angela Cheyne, for their comments, advice and assistance.

Framför allt – Tack till Tina, för att ha stått ut med mig.

Biographical Outline

1930	Born in Hackney, East London.
1939–44	Evacuated to Cornwall.
1944–48	Educated at Hackney Downs Grammar School.
1948	Two terms at Royal Academy of Dramatic Art.
1949	Tried as a conscientious objector. *Kullus* published.
1951–53	Works as an actor for five seasons under Anew McMaster. Tours Ireland.
1954–57	Works as an actor in provincial theatres under the name of David Baron.
1956	Marries Vivien Merchant.
1957	*The Room* is performed at Bristol University.
1958	Daniel Pinter is born. *The Birthday Party* is performed at the Arts Theatre, Cambridge. *The Dumb Waiter* is premièred in Frankfurt.
1959	*A Slight Ache* is broadcast on the BBC's Third Programme.
1960	*The Caretaker* is staged at the Arts Theatre. *The Dwarfs* and *A Night Out* are broadcast on the BBC Third Programme. *Night School* is televised on ARTV.
1961	*The Collection* is televised by ARTV.
1963	*The Lover* is televised by ARTV.
1965	*The Homecoming* is staged at the Aldwych Theatre, following a tour of the provinces.
1966	Receives CBE. *The Basement* is televised by BBC TV.
1968	*Landscape* is broadcast on the BBC Third Programme. *Poems* is published.
1969	*Landscape* and *Silence* are staged together at the Aldwych Theatre.
1971	*Old Times* is staged at the Aldwych Theatre.
1972	Writes *The Proust Screenplay*, never to be filmed.

1973–83	Associate Director of the National Theatre.
1975	*No Man's Land* is performed at the Old Vic.
1978	*Betrayal* is staged at the National Theatre.
1980	Divorces Vivien Merchant. Marries Lady Antonia Fraser. *The Hothouse* is staged at the Hampstead Theatre.
1982	*A Kind of Alaska*, *Victoria Station* and *Family Voices* are staged together as *Other Places* at the National Theatre.
1984	Visits Turkey with Arthur Miller on behalf of International PEN. *One for the Road* is staged at the Lyric.
1988	The first meeting of the 20th June group at the Pinter home.
1990	*The Dwarfs* is published.
1991	*Party Time* is staged at the Almeida.
1993	*Moonlight* is staged at the Almeida.
1995	Awarded the David Cohn British Literature Prize.
1996	*Ashes to Ashes* is performed at the Ambassadors Theatre.
1998	*Various Voices: Prose, Poetry, Politics 1948–1998* is published.
1999	Signatory to Peter Hall's 'Shadow Arts Council'.
2000	*Celebration* is performed back to back with *The Room* at the Almeida.

Abbreviations

Introduction

In the winter of 1995 I saw a production of Harold Pinter's *Betrayal*. It was to become one of a small collection of theatrical experiences that continue to haunt me years after my having witnessed them. I had driven my car across the West Pennine Moors through a blizzard to reach a small converted bowling pavilion acting as the venue for the production, offered by a small group of young enthusiasts touring the North of England. Despite the bitter cold and the snow drifts that were mounting, threatening to keep anyone who ventured out from returning home that evening, a modest collection of people gathered in that room to watch the play. Few of them knew much about *Betrayal*, though some remembered seeing a production of it on television. Most simply came on the strength of its author's reputation.

In many ways the extreme weather outside added to the theatrical experience. The isolation of our little hut, glowing with stage lamps that dark evening, and our huddled mass, fused together in the cold space by the silences and tensions we jointly endured, magnified our awareness that we were being introduced to a different world, one which offered another way of perceiving our own and ourselves, as insecure individuals and as beings who desire connection. As the drama closed and the house lights were raised, a silence remained over the temporary seating as eyes adjusted to meet their partner's and nod in acknowledgement at the shared experience. It was as if the emotional wind had been knocked out of many us, leaving us with nothing to say, nothing to add.

Then, amid the general hum of satisfaction and positive comments, the questions began and conversation stirred. The snow at the threshold kept a number of people from leaving immediately, the company included, and there ensued a polite

discussion between the director, the actors and their public. The disruption that the play had caused in each individual began to surface in the audience's minds and find expression as people tried to categorize what they had seen and how it had made them feel.

Of course, this is a natural response. When any disturbance occurs we need to be able to satisfy ourselves that we know what provoked it, why we were affected by it and how we have adjusted to accommodate it. We do this by applying our rational thought to our impulsive responses and emotions. In short, we begin to try and 'make sense' of what has occurred. A theatrical experience, however, is seldom one that can readily be 'made sense' of. Its communicative power is the kind that is felt and recognized at a less than conscious level, and one that often belies articulation. Certainly, Pinter's work, like that of many of his contemporaries, resists the kind of simple categorization that could be applied to much of the playwrighting that preceded it.

When we do begin to discuss a play in an attempt to clarify it, we usually try to explain why it is of any value, what it has to 'say', and what it is 'about'. Immediately, seeking to answer such questions is problematic. To assume that a play has something to 'say' is to assume that its author has written it in order to convey a particular message. Harold Pinter, though sometimes fuelled by indignation, is much more of an observer than a moralizer, offering us dramatized portraits of human behaviour rather than judgement or ideology. What a play might be 'about' is more often than not only one part of a formula that might make that play a significant piece of theatre. The dramatic manipulation of that 'subject matter' is the more relevant part of the formula. This, after all, is the element that works upon our feelings and nerves when watching any performance. The character of Ruth in Pinter's infamous play *The Homecoming* makes the point most saliently:

> My lips move [...] Perhaps the fact that they move is more significant...than the words which come through them. (*P3* 61)

In the case of *Betrayal*, it is the dramatic device of reversing the chronology of groups of scenes – tracing an extra-marital affair backwards from its sterile aftermath at the start of the play to its passionate inception in the final scene – that illuminates the

otherwise dull, almost clichéd, subject matter (a love triangle between a husband, a wife and her lover, the husband's best friend). If the drama had developed in a logical order, we might have grown to sympathize with characters or dislike them. Instead, our empathy is extended equally to all three characters, because we know the pitiful consequences of their emotional mismanagement before we see the trail of betrayals that has led there. With no proper outlet for any disdain or sympathy, we are consequently forced to look into ourselves, and our own behavioural patterns. As with any Pinter play, it is the form of the drama that delivers its content, whether that be an emotion, an enquiry or moral outrage.

Inevitably, this very basic theatrical fact cannot satisfy those who approach Pinter's plays collectively as a literary achievement, or those who quite legitimately attempt to offer analyses of this most remarkable of writer's impulses and accomplishments. The enigmatic quality of much of Pinter's writing has inspired numerous attempts at interpretation over the years. Initially, his original approach to plot and characterization caused a bewildered response. When public and critics were first exposed to *The Birthday Party* in 1958 the reception was almost entirely hostile. The play was seen as incomprehensible, impenetrable even, and was described by one reviewer as a collage of '*non-sequiturs*, half-gibberish and lunatic ravings'.[1] Only Harold Hobson of the *Sunday Times*, who three years earlier had come to the rescue of Samuel Beckett's *Waiting for Godot* when it received an equivalent critical panning, was prepared to declare the value of the play and state his belief in Pinter as 'the most original, disturbing and arresting talent in theatrical London'.[2] Two years later the world caught up and *The Caretaker* received universal acclaim. As a consequence, Pinter found himself thrust into a critical limelight to which he has been exposed ever since. Though he was soon accepted and integrated into the London theatre system, and swiftly achieved international recognition, he was to remain accused of spinning obscure webs with his writing. It seemed to become a critic's duty to offer explanations that would unlock the plays' mysteries. Accordingly, the three characters in *The Caretaker* have been taken as incarnations of the Holy Trinity; Ben and Gus in *The Dumb Waiter* have been compared to the id and the

3

ego or the mind/body split; *The Homecoming* has been inter-
preted as representing the fulfilment of the Oedipal impulses or
the mating of the goddess of fertility with the conquering ruler
of a domain. In response to such musings, one is tempted to
apply Ralph's words from Pinter's *Moonlight*:

> What do you think this thinking is pretending to do? Eh? It's
> pretending to make things clear, you see, it's pretending to clarify
> things. But what's it really doing? Eh? What do you think? I'll tell
> you. It's confusing you, it's blinding you. (*P4* 342)

The worth of such interpretations nevertheless lies in the fact
that they suggest the kinds of abstract structures in our
sociology, psychology, philosophy and ideology that the plays
might evoke in us through subconscious recognition, though
they never truly imply them. The difficulty with them is that
very often they are the result of an appreciation of the textuality
of the script, and not the theatricality of the play in performance.
In order to satisfy this persistent hunger for quickly digestible
interpretations, one has to assume the plays to be encoded
puzzles that can only bear fruit when dissected and studied in
detail. The character of Len in Pinter's only novel, *The Dwarfs*,
criticizes literary analysts who, when reading poetry 'never
open the door and go in. They bend down and take a squint
through the keyhole' (*TD* 96). Opening the door to Pinter's plays
involves sitting through them, not simply reading the black ink
on white paper of their texts. It is more enlightening if we accept
their enigmatic structures as part of their theatrical fabric,
crafted to ensure that, after seeing one of them, we leave the
auditorium with a semi-digested kernel of 'understanding' at
the pit of the stomach, having perhaps somehow recognized our
own motives, behaviour or fears in the on-stage incarnations
presented to us.

If supplying interpretations of Pinter's scenarios is tricky,
attempting to categorize his work is all the more problematic.
More traditional drama might offer us a story that, through
exposition in the first scenes, first explains how some conflict has
come about and proceeds logically to resolve that conflict either
happily (comedy) or with gruesome consequences (tragedy).
Such a story might involve characters who are easily recogniz-
able and who quickly establish themselves as either heroes or

villains. By contrast, many of Pinter's plays operate by frustrating such basic premises as character, history, motivation and conclusion. Most often, his plays simply involve a given set of characters in a given space vying with one another for domination of that space or of some situation that has arisen there. Language and sexuality become weapons or tools in complex strategies of manipulation and abuse. Frequently, the conclusions are disturbingly open-ended, offering no emotional catharsis or readily digestible statement.

At first, the appearance of disenchanted and directionless youths or rebel figures in neo-naturalistic settings in his early plays suggested that Pinter could be placed alongside the so-called 'angry young men' and 'kitchen sink dramatists' of the fifties and early sixties. Whilst Pinter has always been concerned with the conflict between individualism and conformity which was a chief characteristic of this perceived movement, his plays were hardly the kinds of social commentary offered by, for example, Arnold Wesker in *Roots* or John Osborne in *Look Back in Anger*. At the same time, Martin Esslin recognized that there was a group of European playwrights who seemed to be operating similar agendas and writing plays that frustrated the traditional, narrative impulses of dramatic writing. Including Pinter in this collective, he referred to this perceived new style as 'Theatre of the Absurd'.[3] The works were considered to be absurd in the musical sense, in that they presented man 'out of harmony' with his world, representing a vision of humanity as trapped between an instinctive longing and a world that frustrates that longing. However, only a few of Pinter's plays might belong in this category, which anyway is little more than a form of critical shorthand.

It might be expected that the answers to such questions as what any of his plays could be 'about' or have to 'say' would be provided by a book such as this, which must approach that author's writing not as a collection of individual dramatic experiences but from the other angle: as a body of literary works with a perceived amount of thematic and stylistic integrity. Indeed, one of the purposes of such a book might well be to map out and describe the distinctive features of the landscape that those unfamiliar with Pinter's own particular dramatic territory might appreciate. In attempting to satisfy this need, it will

nevertheless be prudent always to have one eye on the fact that, as a playwright, Harold Pinter writes for the event of dramatic enactment and that his plays can only be 'understood' in the context of their proposed performance and the way in which they have been fashioned to engage with us as auditors and spectators. An audience at a live event is engaged in a social contract between themselves, other members of the public and the action on-stage. The dynamic is clearly different from that of the contract between a reader and a book, where text can be scanned, scoured for meaning, reviewed and put aside before being finished. What is significant in this context is not what the play is 'about' or what it might be 'saying', but what any production of it is trying to 'do' to those who witness it. This 'doing', the gentle assault upon each member of the audience, is the result of the director's, designers' and actors' intuitive responses to dramatic presentation as offered by the author. What I hope this book will address is a consideration of what Pinter, via such intermediaries, has been offering to 'do' to us with his drama over the past five decades.

Comedies of Menace

NEGOTIATIONS AND EVICTIONS

The curtain goes up on an untidy room cluttered with boxes, suitcases, electrical appliances and bits and pieces of DIY hardware. One of the two beds this room contains is free of such junk, indicating that the place must be home to somebody. Sitting on that bed is a young man in a leather jacket. At first he sits still, but then he begins to look around the room as if surveying the many objects it contains. He fixes his gaze on a bucket suspended inexplicably from the ceiling. He then looks out over the lip of the stage into the darkness of the auditorium, his face empty of expression. There is a thirty-second silence – a wait that can seem uncomfortably twice as long in the theatre.

Watching this silent figure, we in the audience might gather from his slow consideration of his surroundings that he is a stranger to the place, or we might presume that the room we find him in is in fact his own and that he is despairing of its state. During his thirty seconds of fixed silence, we are given the time to absorb the details of the room and wonder what the character might be waiting for. A minor anticipation is allowed to develop as we expect an imminent introduction. When we hear a door bang and muffled voices, we sense that our curiosity is soon to be satisfied. Instead, the young man quietly stands, goes out through the door and closes it gently behind him. There is a third silence, a dramatic punctuation mark that neatly closes that first short scene and allows our gentle surprise and disappointment to establish themselves. Then in come two men: a polite fellow in smart but old clothes and a tramp-like old man who seems rude and edgy. The first of these comes across unambiguously as the

room's occupant, as he enters first, pockets the key, closes the door and immediately invites his guest to take a seat. The first man speaks little, is kind and simple-natured. The tramp is evasive and clearly out to gain as much as he can from his companion's generosity. We recognize a charged dramatic scenario with clear comic potential. But the swiftness with which we make the acquaintance of these two characters emphasizes the minor enigma of the man in the leather jacket. Why had he been in the room and what did he have to do with either of these two men? Our unsatisfied curiosity can only flavour our experience of the subsequent action.

The play, of course, is Harold Pinter's *The Caretaker*, written in 1959. The enigmatic figure is Mick, younger brother to the compassionate but exploitable Aston who has rescued the tramp Davies from being roughed up and will offer him first a place to stay, then a post as caretaker to the house he has yet to fit up and decorate. But Pinter chooses to keep the key information of Aston and Mick's relationship from the audience until well into the second act. When Mick returns in the final moments of the first act silently to watch Davies and then attack him, we still do not know who he might be and what danger he might represent to either established character. Throughout the first act, Davies has come across as a plainly questionable but fairly ineffectual character and the only harm he seems to represent is that of an irritant scrounger who provides a litany of excuses for not getting himself gainful employment and his own digs. For the most part, we have laughed at him and his justifications, been amused by his account of his treatment by the Luton monks and tittered at the figure he cuts in long underpants. All of this makes Mick's violent assault on him all the more unexpected as the old man is reduced before our eyes to a pathetic, helpless beggar. We fear for him as he seems to be getting more than any comeuppance we might have wished upon him, and we extend some of that fear for Aston's possible return. Is this how he will be treated too? Only several minutes later (or longer if an interval is observed between acts) is the leather-jacketed figure given a context that we, as an audience, can finally relax with. This is halfway through our evening at the theatre.

By choosing to set an enigma into operation in *The Caretaker's* first minutes and profiting from all its dramatic worth, Pinter is

perpetrating an act of menace upon his audience and we find ourselves contracted into a theatrical experience which is relatively less comfortable than might normally be expected. He denies us any direct access to a quick assimilation of what his play might have to say by refusing us any definite exposition of his characters. In doing so he makes a dramatic virtue of ambiguity, striking a tone of pervading uncertainty which serves to qualify and magnify our response to the drama. This quality of menace is typical of Pinter's early dramas, and mystery and ambiguity of intention and meaning have always surrounded his writing. Pinter's significant achievement here, is the development of a starkly original contract between audience and performance, one which serves not just to facilitate the flow of information, but which in itself acts as a kind of commentary, fusing the play's content with the form in which that content is being delivered.

Traditionally, a playwright would first establish defined characters and then have them behave relatively predictably in the resolving of some crisis between them. The 'theatricality' of this type of drama was the manner in which the audience would be emotionally engaged with the characters and the tensions and releases that could be engineered within that attachment, bringing about satisfaction when the dramatic crisis was resolved. Pinter's manner of presenting his characters and allowing them to develop unpredictably before us is central to his own distinctive theatricality, one that operates by extracting our association with characters outside of any moral structure that a crisis might usually construct. In other words, we associate with these characters not because we approve of their behaviour, but because we recognize the predicaments that frustrate their existences. Mick might come across one minute as sadistically brutal and the next as his brother's compassionate benefactor. Davies, too, alternates between the devious and the pathetic. Even Aston, though he maintains our sympathy throughout, can certainly stretch our patience. With no stable emotional location for empathy, our consequent experience of such a play in performance is fragmented. Our recognition of the human dilemmas being portrayed is nevertheless clear. Aston's trust and Mick's distrust of Davies, and the tramp's very real need for recognition, all combine to create an imbalanced

network of needs and desires. There might be no traditional crisis in operation in *The Caretaker*, but its theatricality provokes in us a desire to see the structural flaws of this network resolved.

Each of the three characters' existences is essentially empty, but their attitudes towards breaching the hollow are different. Davies's interaction with others is a process of denial of his own inadequacies. Indeed, deferring responsibility seems something of a survival mechanism for him. He fails to see how his own behaviour has caused him to lose his job, how he might well have been the instigator of the fight from which Aston saved him, or even simply that Aston's questions about his name and Welsh identity are not intrusive queries but innocent attempts at making friendly conversation. He is so dependent on self-affirmation through negation of others that he has an over-developed paranoia which manifests itself in fear of the authorities (who might lock him up for using an assumed identity) and of foreigners: the blacks, Greeks, Poles and Scots he blames not only for his own lack of employment and homelessness, but even for the nocturnal noises he himself emits. Even his use of terms such as 'if you like' or 'good luck' (*P2* 6 and 14), when one might expect expressions of gratitude, indicate that he will not accept that his condition might inspire gestures of charity. When blame cannot be apportioned to others, then it is the weather and the need of a good pair of shoes that bar any personal development and stop him getting down to Sidcup to pick up his papers. These papers, whatever they might be, might restore his dignity and worth. And yet whenever Aston offers him a decent pair of shoes to facilitate his life-asserting trip to Sidcup he finds fault with them and rejects them. Evidently, Davies never intends making it to Sidcup for this would imply a pro-active attitude to life and responsibility.

The play operates, then, as a study of prevarication. All three characters lack any real dynamism, and their purposeful boasts are given the lie by their inability to effect any significant change. Even Mick seems to be as much a victim of his aspirations as Davies is of his fabrications. His vision of the 'palace' (*P2* 58) into which he hopes to transform the dingy flat might simply be another diversionary tactic articulated to hoist Davies up by his own petard, but the surrounding clutter nevertheless represents quite visibly a heavy ball and chain to

his progression as a builder and prospective landlord. The heaviness is also an apt metaphor for his relationship with his brother, in whom he has perhaps encouraged the therapeutic illusions of an ability to decorate the house. When he finally loses his temper with Davies and smashes Aston's Buddha figure, his anger and desperation have three directions: the violent action definitively punctuates his decision to lay off Davies as caretaker, but it also emphasizes his despair both with his own unrealized aspirations and with his brother's condition. Pinter's decision to add and use this particular prop in this way can hardly be by way of a whim. The calm and serenity universally associated with the icon reflects and externalizes Aston's simplicity and gentle, matter-of-fact attitudes. Its aesthetic presence within a crudely functional environment invests the space with a spiritual, dignifying quality and its breakage represents both a point of no return and a coming to terms with hard realities.

Aston, too, is guilty of procrastination, though his ambitions are clearly more realistic and immediately realizable. And yet, his collected junk visibly conveys his burden, and the thickness of his defences. His plans to decorate his brother's property seem of crucial importance to him and the task seems intrinsically linked with the trauma he recounts of electroshock treatment. In order to move on, to prove that he can cope, he holds out his ambitions for the flat as an enticing distraction from the possibility that much of it might be beyond his abilities. Before he can decorate the flat he has to build his shed, and before he can build his shed he needs to clear the garden, and before he can attend to this there will doubtlessly be a list of trivial tasks to accomplish such as mending the plug to the toaster which we witness taking a fortnight, no less, of his attention. Many of us might not be capable of interior decoration, or of constructing a shed from planks of wood, but few would be overcome by changing a plug. Reconciling this awareness with hearing Aston's words and watching his deeds, we cannot help but feel both admiration and despair for the character.

In Aston we recognize a lost innocence, a nonjudgemental attitude that defines itself by an ability to progress slowly upon a specific chosen path. In Davies we recognize our desires to suppress knowledge of our own inadequacies and to be motivated by bitterness. In Mick we recognize our capacity to

get by on wit and self-confidence, hoodwinking the rest of the world but not ourselves. When we leave the theatre we are left with the emotional residue of the hopeless contact between these three characters, and the essentially tragic inability of one man to build upon the trust, respect and friendship offered unconditionally by another. That unbreachable space between Davies and Aston is most clearly physically articulated in the final tableau, in which Davies pleads in ever fragmenting sentences to Aston, standing with his back to the old man, to allow him to stay. This void, perhaps, is the kernel of the play's concern: it demonstrates how we manage to undermine our own search for emotional comfort and companionship. In couching this in terms of a series of confrontations between three self-deceiving loners, the play also comments on human aspiration, and the way in which we use ambition to deceive ourselves about our status in the world and to avoid contemplation of our wretchedness.

The positive reception that critics and public offered *The Caretaker* in 1960 represented Harold Pinter's breakthrough as an artist. It was described as a 'riveting, uncompromising piece'[1] and heralded as 'a kind of masterpiece'.[2] Previously, however, his works had been almost universally greeted with bewilderment and this was perhaps due to their more enigmatic qualities and allegorical structures. *The Birthday Party*, his first significant inroad into the theatres of the London West End, received a particular critical bashing, and was snubbed typically as 'random dottiness'.[3] It was perhaps the greater realism of *The Caretaker* that was its saving grace, and which opened up the possibility of Pinter's being received with more serious attention. In essence, though, *The Caretaker* was a refinement of the kinds of thematic concerns that had driven much of Pinter's writing to date. It offered a precise examination of the human impulse to dominate, to define areas of territory, and the ability of an intruding figure to intercede in such things. Pinter's first three plays, *The Room*, *The Birthday Party* and *The Dumb Waiter* (all 1957), alongside such early prose works as *Kullus* (1949) and *The Examination* (1955) are all different manifestations of this obsession with the violating presence of an intruding force. Significantly, all these works share a manipulation of space as characteristic of these violations. Furnishings and decorations on a stage are not only indices of

occupancy, but also become stamps of identity. As such, a character's environment is as articulate of his mood, and its manipulation as articulate of his vulnerability, as anything he might say or do. It is evident that much of Pinter's early dramatic writing hinged upon this simple premise, involving negotiations for supremacy between occupants and invaders of territory, and thereby providing commentary on the nature of our interaction as social and emotional beings.

The Room, written over three days in 1957 at the request of his friend Henry Woolf,[4] was Pinter's first work for the stage, and might be considered an embryonic treatment of some of the themes that were to be prevalent in *The Caretaker*. Both plays, for example, end with the defeat of what might be construed as a father figure. But whereas the linear development of *The Caretaker* is both theatrically satisfying and self-contained, the one-act *Room* is not quite so structurally intact. At first glance it seems that the play presents a very straightforward existential allegory in which the 60-year old Rose Hudd, an occupant of a warm, homely room in a large house, feels menaced by the dark, icy outside world and is made insecure about her continued tenancy of her home. As such she appears to stand as a representative of all humanity, fearful of a world that conspires against the individual's need for stability and assured personal identity.

Set within a bedsitting room, with a stove, a double bed, an armchair and dining table all visible, the play is clearly taking place in a home, where all elements of human habitation are contracted into one space. As if to emphasize this, the play opens with a scene of absolute domesticity: Rose preparing bacon and eggs for her husband, who consumes his meal silently, his nose in a magazine. Within this scenario, Rose is dramatically privileged and attains our attention during her long, uninterrupted opening monologue. We learn of how she cherishes their room, is thankful for the protection it offers from the wintry outdoors and is wary of the cellar and its new tenants. However, by constantly reaffirming her contentment with the room, Rose is already revealing an ingrained fear of eviction. When their landlord Mr Kidd pays the couple a visit and reveals that the place used to be his bedroom, he sets in motion a dramatic momentum by which Rose is progressively dispossessed of her identification with the room. This is

aggravated by the arrival of Mr and Mrs Sands who, having come to view a room, tell Rose that the landlord they have spoken to in the cellar has informed them that hers is vacant. That the landlord they have met is not her landlord, Mr Kidd, further disinvests Rose. Finally, the mysterious tenant of the cellar arrives, a blind black man named Riley. Claiming to speak on behalf of Rose's father, and seemingly as her father, he begs her to return home, closing the movement which has demonstrated that, in spite of her efforts, Rose cannot claim to belong where she would. Referring to her as Sal, which Rose seems to accept as a former name by the manner in which she protests too much his use of it, even her identity is finally laid bare.

On one level, then, the play offers its audience a reflection of our daily needs for the security of identity, reconfirmation, and the avoidance of repressed anxieties. However, *The Room* is thematically impure in that the slow movement towards Rose's collapse, and spiritual death in the blindness that ultimately afflicts her, is distorted by what appears to be an undercurrent of sexual politics. Ten years her husband's senior, Rose is characterized as a wife/mother archetype, eagerly feeding Bert and ensuring he is adequately wrapped up to go out in the cold. A similar tension exists between Mr and Mrs Sands, with the husband even retorting 'Who did bring me into the world?' (*P1* 100). Accordingly, the apparent existential angst that the play generates is reduced to being a female characteristic, diminishing the theatrical effect this might have as a communication of universal suffering. Both Rose and Mrs Sands speak of the damp and dark that the house generates, and both sense the hostility of the outside ('it's murder' they both declare (*P1* 85 and 95)). Rose's husband, however, is capable of cutting through the winter weather at full speed in his van, oblivious to the danger the ice represents, and Mr Sands is capable of seeing through the dimness of the cellar. When, in the final moments, Mr Hudd returns to discover his wife alone with Riley and, speaking for the first time, describes his control of the van in violently sexual terms only then to set about beating up the intruder, kicking Riley's head against the gas stove, he is hardly the redeeming protector returned to safeguard their hearth and home. Instead, it seems, he has finally articulated his dominance over both his woman and his abode. The insertion here of an apparently

political theme perverts an audience's responses further. Riley in appearance and name represented the two ethnic identities – blacks and Irish – that were commonly excluded from tenancy rights in post-war Britain. The sight of this man being brutally injured or killed could hardly be devoid of political resonance either then, at a time of great social unease over issues of race and immigration, or today when racism is more insidiously present in society and its institutions.

All this makes for a powerful drama, but one that fails perhaps to find an articulate focus. With *The Birthday Party*, Pinter resolved this by better separating the sexual interaction and the oppressive forces that operate on the characters, and by making any potentially political commentary more oblique. This also holds true of *The Dumb Waiter*, in which a sharper socio-political concern was beginning to take shape.

Written in 1957, *The Dumb Waiter* is set in a basement apartment that was once, it would seem, the kitchen to a restaurant above. The two rooms are interconnected by the dumb waiter of the title, a service hatch by which orders and meals would once pass up and down. As the play opens we find Ben and Gus on two beds, two working-class Londoners idling away the hours with titbits from a newspaper and chatter about tea and crockery. Their banter is light-hearted but the difference between the two men's attitudes establishes a tension that is to escalate and form the chief theatrical texture of the piece. Ben is relaxed, and spends most of the time on his bed reading his newspaper. Gus is restless and frequently wanders about or goes off into the kitchen or lavatory. The tension between them, as Gus chats idly while Ben would rather sit and wait in silence, builds into petty power struggles (does one say 'light the kettle' or 'put on the kettle'? (*P1* 125)) and eventually ignites into restrained violence between them. We soon learn that these are two hitmen on a 'job' in Birmingham, awaiting the arrival of their latest target. We understand that they represent one branch of a large, and clearly well-structured 'organization' and that they receive their instructions from a man named Wilson. But 'this time' things are not as incident-free as the two might normally expect, and Gus is manifesting signs of disaffection with his employers. He complains about the conditions of their employment and bemoans the manner in which he feels they

are neglectfully treated. As a pathetic, clownish figure he solicits both our sympathy and our laughter. With Ben as his 'straight man', the two are very much a double-act, and much of their chatter has all the qualities of a music-hall comedy routine.

But this play is no straightforward comedy. Forces beyond these men's comprehension and control are operating upon them, and their responses take on both farcical and tragic resonances. An envelope containing twelve matches is inexplicably shoved under the door, initiating the first measure of menace that is applied to the two characters. Its appearance indicates a shift in the drama as an audience realizes that the humour is to take on a darker tone. Nonplussed by these matches, the two men presume they have been sent to them for their use, noting that they can now light the gas and make some tea. But as Gus puts the kettle on to boil the gas runs out, being on a pay meter. Then the dumb waiter between their two beds, the chief agent of menace in this play, trundles noisily into operation. Incomprehensibly, with each descent it brings orders for food. At first the requests that arrive on slips of paper, though baffling, make some sort of sense to the two men. The British fare of, for example, steak and chips or liver and onions (*P1* 131 and 132) that is ordered might be explained away. 'It probably used to be a café here, that's all' (*P1* 132) Ben rationalizes. But then requests come for more and more exotic sounding dishes, first for European cuisine and then for East Asian food. We in the audience first share Ben and Gus's confusion, but as the more plainly ridiculous requests come down, our responses diverge and, as we witness the two men's panic and laughable attempts to satisfy the demands made of them (they send up all they have: biscuits, tea leaves, crisps, an Eccles cake, a chocolate bar, and a bottle of milk), we begin to get an inkling that Ben and Gus are being toyed with. In the panic induced by the intervention of this mechanical third character, Gus interprets the requests as some kind of test being placed upon them by their organization:

> What's he doing it for? We've been through our tests, haven't we? We got right through our tests, years ago, didn't we? We took them together, don't you remember, didn't we? We've proved ourselves before now, haven't we? We've always done our job. What's he doing this for? (*P1* 146)

16

If they are being tested, Gus has been failing at every turn. Unlike Ben, who decides it is better to send up the wrong food than no food, who speaks through the speaking-tube 'with great deference' (P1 139), and who is constantly ready for action, Gus is indecisive, clumsy, and ill-prepared. Ben berates him for being lazy, slack, and for not checking or polishing his gun. Significantly, he asks no questions about their orders, whereas Gus constantly questions their work, asking Ben who their hit might be that evening, who owns the place they are staying in, and who clears up after them. 'You never used to ask me so many damn questions' Ben complains, 'What's the matter with you?' (P1 127). From the outset Gus has had something on his mind and, though he often repeats that he has something to ask Ben, he cannot easily get around to articulating what the matter is. Early on he asks his partner: 'Don't you ever get a bit fed up' (P1 118), indicating indirectly that *he* does. Later he dwells on their last job. This has clearly been troubling his conscience, as the image of the bloody female corpse has stuck in his mind: 'They don't seem to hold together like men, women. A looser texture, like. Didn't she spread, eh?' (P1 130–31) He eventually confesses that 'it was that girl made me start to think' (P1 131) and, once Ben has run through their instructions, worriedly asks 'what do we do if it's a girl?' (P1 144). Even his assertion in the play's first moments that the girl of 8 who, in Ben's newspaper, is reported to have killed a cat had probably been set up by her brother, indicates that he has developed a set of gender-related value judgements that might now impede his reliability as a hired killer.

The dumb waiter, then, seems to serve as the tool of some higher organization which might separate the wheat from the chaff. Gus's behaviour and changing attitudes implicate him, whereas Ben remains the consummate professional. Gus, too, is a dumb waiter, in that he must wait with ignorance of his fate. Impatient and questioning his job, he has also become an inadequate waiter, and this is to prove his downfall. The basement adds to the symbolism of his predicament, for here he is entrapped and literally 'kept in the dark'; arriving and departing during the night, unsure of and unable to see the outside. Disoriented, he even needs to be informed which city he is in. It is an apt decor for these two men, blinded by duty and blind to the increasingly apparent truth.

The sting to the play is in its tail. When Ben receives information down the speaking tube that the evening's victim is about to arrive, he hurriedly prepares himself and calls for Gus to return from the lavatory. But Gus is thrust on instead through the door as the victim 'stripped of his jacket, waistcoat, tie, holster and revolver. He stops, body stooping, his arms at his sides' (P1 149). In this way, and unlike the other two enigmatic plays of 1957 (*The Room* and *The Birthday Party*), *The Dumb Waiter* clarifies its mystery in no uncertain terms with this sudden burst of enlightenment in its final seconds. One might consequently claim that the play is a puzzle with a specific point to make, providing a final revelatory scene in the same manner as the more overtly political *Hothouse* (1958). Yet, although we could conclude that the play is critical of organizations or social structures that require and make virtues of submission and unquestioning obedience, dehumanizing and exorcizing individual thought in the process, it is patently not geared uniquely towards communicating such a message. Its chief theatrical device, the Machiavellian *deus ex machina* of the dumb waiter, has other, far-reaching, metaphoric resonances that we also carry with us from any performance of the play. Its random intervention into these two men's existence might remind us of our own daily efforts to make sense of an erratic world that defies prediction. We might recognize in their panic our own endeavours to assert ourselves and secure confident identities in the face of exposing realities. It is tempting, then, to read this play of waiting, verbal battles and game-playing as a form of metaphoric waymark, hinting at metaphysical structures. Gus complains that their boss Wilson 'might not come. He might just send a message. He doesn't always come' (P1 128) and this adds to the weight of pointless, ambitionless waiting that has come to define his life. We all wait for redemption and release, and ignore the mortality that both effects and negates these matters. In this way, like *The Room* before it and *The Caretaker* after it, *The Dumb Waiter* offers a painfully recognizable portrait of the human condition.

Detecting such themes in Pinter's early works, Martin Esslin named him as an author of the 'Theatre of the Absurd', placing him alongside such writers as Samuel Beckett and Eugène Ionesco, artists who sought 'to make man aware of the ultimate

realities of his condition [...] to shock him out of an existence that has become trite, mechanical, complacent, and deprived of the dignity that comes of awareness'.[5] He viewed Pinter's characters as being:

> in the process of their essential adjustment to the world, at the point when they have to solve their basic problem – whether they will be able to confront, and come to terms with, reality at all.[6]

Certainly, it is these individuals' confrontations with external forces, obliging them towards conditions which they attempt to resist, that governs the dramatic energies of Pinter's early plays, and it is a measure of their worth as pieces of theatre that these confrontations successfully convey both existential and implicitly political suggestion. When Irving Wardle famously applied the term 'comedy of menace' to Pinter's works, it was to denote this double-edged capacity to disturb that Pinter had crafted, through the flippant application of dark humour to situations in which characters were forced to face an implacable destiny:

> Destiny handled in this way – not as an austere exercise in classicism, but as an incurable disease which one forgets about most of the time and whose lethal reminders may take the form of a joke – is an apt dramatic motif for an age of conditioned behaviour in which orthodox man is a willing collaborator in his own destruction.[7]

The early plays function, then, by providing metaphoric structures that might resonate with an audience's own experience of social, familial or political obligations, those irrepressible forces that govern all our fates. Davies, Aston, Rose, Ben and Gus enact the symptoms of our being, and our theatrical relationship with such characters is one of recognition, both comic and pathetic, structured within the menacing framework of ambiguity.

A well-known characteristic of Pinter's dramatic writing, and another perpetrator of menace, is the infamous 'Pinter pause'. Its most common incarnations are as the simple indication 'pause', the more significant 'silence' and the less obvious three trail dots all slipped into scripts at appropriate moments. To Pinter's mind, their presence is a matter of common sense and they are 'not formal conveniences or stresses but part of the body of the action'. He states that if actors play his scenes

appropriately 'they will find that a pause – or whatever the hell it is – is inevitable'. The writer has sought to dismiss the critical emphasis that has been placed upon these distinguishing features of his drama:

> The pause is a pause because of what has just happened in the minds and guts of the characters [...] And a silence equally means that something has happened to create the impossibility of anyone speaking for a certain amount of time – until they can recover from whatever happened before that silence.[8]

At face value, then, these pauses, short pauses, silences and trail dots are simply codes for actors and their directors, suggested pointers to the rhythm of each scene. They add weight to a scene and their very conspicuous presence in the script acts as a form of score, providing a suggested tempo at which each scene might be played. Consider, for example, the density of pauses following the entrance of Aston in the second act of *The Caretaker*. During the previous five minutes of the action, Mick has physically overpowered Davies and has persistently browbeaten him with a barrage of questions and accusations. Included in this verbal assault are three brief speeches characterized by short, staccato sentences and clauses piled one on top of the other in quick, uninterrupted succession. Then Aston walks casually in with Davies's recovered bag:

> *Silence.*
> *A drip sounds in the bucket. They all look up.*
> *Silence.*
> MICK. You still got that leak.
> ASTON. Yes
> > *Pause.*
> It's coming from the roof.
> MICK. From the roof, eh?
> ASTON. Yes.
> > *Pause.*
> I'll have to tar it over.
> MICK. You're going to tar it over?
> ASTON. Yes
> MICK. What?
> ASTON. The cracks.
> > *Pause.*

MICK. You'll be tarring over the cracks in the roof.
ASTON. Yes.
 Pause.

(P2 35)

The atmosphere of menace that has been built up in the scene between Mick and Davies is shattered abruptly in a silence, reduced and released by the comic effect of the three characters visually responding in unison to the drip and laid to rest by a series of pauses. But these short gaps in the slow, repetitive and meaningless dialogue between the two brothers not only participate in indicating to the audience something about the nature of Mick and Aston's relationship (the kind of emphases that actors seek), they also announce the beginning of the next 'movement' in the drama (something the more discerning directors will want to pursue). It is an example of the way Pinter manipulates the drama's form (pace and pitch) not only to inform the content (hostilities, affections, manoeuvres for advantage) but also to induce a kind of musicality which, when judiciously executed on-stage, can affect the audience by the collision and collusion of its disparate rhythms.

The character of Len in Pinter's 1950s novel, *The Dwarfs* (unpublished until 1990), criticizes those who appraise literature by climbing 'from word to word, like steppingstones', and asks how they might analyse 'a line with no words in it at all' (*TD* 97). This, as good a description of Pinter's pauses as any, might represent part of his artistic ambition. Rubbishing textual analysis, Len instead extols the power of absence as an affective mediator. In total accordance with this view, Peter Hall recognized, during the rehearsals for *The Homecoming* in 1966, that 'what was not said often spoke as forcefully as the words themselves. The breaks represented a journey in the actor's emotions, sometimes a surprising transition.' He was aware that pauses and silences not only inform a play's atmosphere, they might also be indicative of a pervasive subtext implanted by the author at any one point in the manner in which any silence tempered the words that surrounded it. Consequently he set aside rehearsal sessions in which he would force his actors to concentrate on the 'dots and pauses'. 'Otherwise, the surface of the play will seem bland and pretentious. And the pauses will mean nothing.'[9]

21

Despite its undeniable significance as a dramatic device, silence also adds its weight to some of Pinter's prose writing and, in doing so, indicates to us its significance to him as an act both of assertion and of resistance. In a brief piece entitled *The Problem* (1976) the protagonist agonizes over a telephone malfunction. The manner in which a device that facilitates communication becomes a purveyor of menace extends from the placement of silence where a conversation might normally occur, and silence and isolation effectively disempower the narrative voice. Similarly, silence manipulated as a tool for the negotiation of advantage occurs in *The Examination* (1955), a short prose piece which pre-dated Pinter's dramatic writing. The first-person narrator of this short story relates his task of having to interview a character named Kullus and the shift in power that occurs between them in the form of territorial loss via the control of silence. The tone of the piece is almost a confessional one, coloured as it is with insecurity and documentary detail. The examination of Kullus takes the form of a series of talks in the narrator's room, punctuated by intervals permitted by the narrator and silences imposed by Kullus. At first the narrator is happy to assent to Kullus's silences, priding himself on his 'tactical acumen' (*VV* 83). He feels no need to distinguish between silences within the frame of the examination, which he takes as an articulation of sorts, and those outside that frame, his generous intervals. Eventually, though, the silences before and after intervals begin to bleed into these intervals, so that together they become 'indistinguishable, and were one silence, dictated by Kullus' (*VV* 86). Resigned, the narrator confesses that Kullus 'journeyed from silence to silence, and I had no course but to follow' (*VV* 84). In this way a struggle for control over the duration of silences becomes tantamount to a struggle for territorial gain. Kullus's sly domination of the dialogue via acquisition and imposition of silences reinforces his claim to the territory of the examination, which he further asserts by his frequent refusals to sit. Eventually, he gains sufficient confidence to remark upon the absence of a flame in the grate, to acknowledge the stool, remove the blackboard and close the curtains. Recognizing in the story's final line that 'we were now in Kullus' room' (*VV* 87), the narrator gives in.

The invented name Kullus,[10] perhaps by its evocation of words such as incubus, succubus or culling, suggests vampirism, the sapping of strength of those he confronts. But the other-worldly nature of this name also creates a sense of facelessness, of impersonality. Appearing in prose, which is absorbed quite differently from drama, on a more personal, cognitive level, the character merges with the preoccupations and anxieties expressed by the narrating voice, as if a personification of those concerns. The 'character' of the matchseller, a dramatic incarnation of silence in the enigmatic figure of a mute down-and-out, serves this same function in the radio play *A Slight Ache* (1958),[11] becoming as much part of the auditor's mindscape as that of the afflicted protagonist. In this work the daily appearance over a two-month period of this tramp-like matchseller at his back gate disturbs the comfortable middle-class serenity of Edward, a writer of sterile theoretical essays. Confronting the man, who offers no response to any line of questioning, Edward's frustration manifests itself in increasing distress and paralysis. For his wife Flora, however, the character's invitation into their country house seems to signal a kind of rebirth, a rejuvenation of her sexual identity.

The play opens with a dialogue between the married couple over breakfast, during which a picture is painted of bickering partners in a barren relationship well past its prime, but materially comfortable in their spacious country house with its lush garden. The majority of the play, though, takes the form of a series of speeches between Edward or Flora and the matchseller. Broadcast on the radio these speeches are ostensible monologues, interrupted by pauses and silences in which the matchseller is expected to respond to questioning or provocation. Gradually, though, as the pauses take on an oppressive dynamism of successive inevitable silences, the listener cannot but begin to question whether or not this matchseller is anything but a figment of his interrogators' imaginations. Colluding with this impression, we hear none of the breathing, grunting, laughing or crying that is alluded to by the two vocal characters, though there are audible footsteps and noise at the dropping, collecting and manipulation of the tray of matches. Lacking, however, any real evidence that the matchseller is a physical presence in Edward and Flora's house, the listening

audience begins to invest hope for elucidation in the silent character, paralleling Edward's plight. Just as Edward cannot be comfortable until he has discovered what the matchseller is about, so do we begin to require explanation, and hope that some utterance from the figure will offer us clarification as to what this mysterious radio play is trying to say. Of course, we are ultimately denied this and the resultant frustration is part of the intended experience. Dramatically, the effect is like that of a spring being slowly wound up, and this tension is deposited in the slight ache that Edward experiences behind the eyes, one that slowly builds into a debilitating headache, causing his ultimate collapse in the play's closing minutes.

Faced with persistent silence, the characters' probing of the matchseller for answers effectively serves to reveal their own preoccupations and uncertainties. For Edward, the tramp's pointless insistence on selling matches on a track where few people pass by is a source of disquiet. What is more, that the man has chosen to carry out this futile occupation outside his own back garden gate is taken as an invasion of his own territory, getting in the way of his enjoyment of his surroundings:

> EDWARD (*to himself*) It used to give me great pleasure, such pleasure, to stroll along through the long grass, out through the back gate, pass into the lane. That pleasure is now denied me. It's my own house, isn't it? It's my own gate. (*P1* 159–60)

In this way the tramp's presence is analogous to the slight ache behind his eyes that Edward has complained about; it is an irritant that shows no sign of going away and which disturbs an otherwise comfortable existence. Indeed, when Flora, after catching her husband spying on the strange figure from the scullery, dares to suggest that he is 'frightened of a poor old man' (*P1* 162), Edward's pain flares up. As if then to attribute that pain to the matchseller, he slowly declares that he wants to have a word with him. Once face to face, this physical connection continues. After a barrage of pleasantries have failed to break any ice, and the discovery that the matches are damp, Edward finally manages to get the tramp to sit down, only to be so overpowered as to need to go out for fresh air. Later, following more failed interrogation, Edward sneezes,

complains about the germ he has caught in his eyes and falls to the floor, where he is to remain for the rest of the play. Despite his protestations at this point that his sight is excellent, his faculties are clearly fading in the presence of the old man. Earlier he had failed to notice the flowers blooming and could not hear a wasp buzzing or the birds singing and flapping their wings in the trees around the garden. Now he believes the old tramp seems younger-looking and speaks in terms of someone who can no longer see: 'It must be bright in the moonlight', 'The pool must be glistening. In the moonlight. I remember it well' (P1 183). The references to moonlight serve a poetic purpose perhaps, as well as indicating the darkness that has physically overcome Edward at lunchtime, when Flora has raised the canopy against sunlight. Clearly, the powerful silence of the matchseller initiates notions of weakening faculties, of anxieties of ageing and, ultimately, of death. Martin Esslin draws an interesting comparison with the silent figure of death in Ingmar Bergman's film *The Seventh Seal*, itself an adaptation of a 1954 radio play *Trämålning* (*Painting on Wood*), in which the menacing presence manifests itself uniquely in silence.[12] The matchseller certainly operates on a similar level, as a manifestation of all the questions of existence that cannot be answered.

Early in the first moments of the play, Edward captures an intruding wasp in an earthenware marmalade jar and, by pouring hot water down the spoon hole, kills it.

Ah, yes. Tilt the pot. Tilt. Aah...down here...right down... blinding him...that's...it. (P1 158)

The reference to the blinding of the insect is curious and briefly draws attention to itself, initiating not only a theme of sightlessness, but also one of power and subjugation. The irritant wasp is easily blinded and squashed, but any attempt to wipe out that other irritant intruder clearly proves to have the opposite effect. In the final moments of the play, when Edward takes the match tray that his wife passes to him it is as though he is accepting his burden, and physical blindness takes on the shape of metaphysical penance. After Rose (*The Room*) and Stanley (*The Birthday Party*), he resembles other such Pinter characters who, flawed but seemingly innocent, are forced to shoulder the burdens of guilt that are visited upon them.

Though conceived as a piece for radio, *A Slight Ache* persists as a stage play, and its published form caters for this. However, the transformations that the shift to the stage necessitate are the cause of an evident weakening of the text's dramatic potential. The first and most obvious is that the matchseller now takes on a physical presence who, standing and staring in silence, might come across as more of an imbecile than a metaphysical threat. Donald McWhinnie, who produced the original radio broadcast of the play and directed its first stage production, attempted to maintain some of the mystery by at least denying the audience a view of the tramp's face, keeping his back to the audience for the most part. On radio, the character can quite vividly metamorphose in the minds of the audience as his description adapts in accordance with Edward and Flora's mental states. His physical shape shifts from a sagging, sweating, mud-caked jelly with a glass eye to 'a solid old boy' (*P1* 176). Later, he is described as 'a hump, a mouldering heap' (*P1* 179) with a lopsided grin, only to transform into a youthful 'stripling' (*P1* 183). On-stage his visibility makes liars of those who describe him. Sound is also a premium on radio and whilst the playing of a wasp buzzing, for example, might seem a ridiculously fastidious attempt at naturalism on stage, added to Edward's irritation at his wife's banal conversation it makes more of his pettiness. As the wasp resounds in its earthenware jail, waiting to be scolded, the visual image of a marmalade jar is brought up close in the mind's eye. The sharp, frenetic sound underscores the vindictiveness with which Edward is to treat the next intruder but also sets in motion a theme of entrapment more successfully than any distant, visible prop might. The stage adaptation of *A Slight Ache*, then, suffers slightly from the transformation. The actual reality of an actor in the role of the matchseller creates a dynamic that directors need to overcome. The focus of shifting audience eyes and minds needs perhaps to be maintained upon Edward and Flora and away from the facial and gestural reactions of their odd guest, who possibly must come across as more of a significant presence than an individual. Otherwise an audience's eyes can now focus away from concerns first manifested in voice alone and the result is a potential magnification of any apparent symbolism, detracting from the ambiguities that ought to be allowed to operate.

A perceived dramatic weakness of *The Room* was in the clash between the play's apparent tendency towards universal representation of the human anxieties of identity and belonging and the very clearly delineated differences between male and female behaviour and attributes. A similar accusation might be levelled at *A Slight Ache*, in which the different responses to the matchseller of Edward and Flora seem to unpick and confuse the allegorical structure of the play, and while Edward's descent is understandable and occurs at its own irrevocable pace, the elevation of Flora seems gratuitous and simplistic.

The sexual theme is introduced from the drama's very first words with the innuendo at play in the proximity and repetition of words such as convolvulus, clematis, toolshed, and honeysuckle. Flora's name, though we never hear it spoken, inevitably ties her to the potent, flowering garden. It is perhaps also significant that she declares it to be the longest day of the year, with midsummer being traditionally allied to flirtation, mate seeking and lovemaking. Once left alone with the matchseller and with initial pleasantries out of the way, Flora claims that the man reminds her of a poacher who once brutally raped her on a cattle track. Much has been made of this reference as Flora's expression of her sexuality, though it smacks more of a male domination fantasy than a female fantasy of deferred responsibility. The glorification of rape is perhaps irresponsible, but what is clear from Flora's account, which she voices in easy, even poetic terms, is that for her the matchseller is a figure of potency, quite unlike the vampiric posture her husband endures. Coming so soon after Flora's descriptions of a recent flood that carried whole families away, a reference that does seem planted to invoke our awareness of scripture, it is as though the potential betrayal of woman through her own sexual awareness is being evoked as a theme here, with oblique references to the original sin: Flora's assailant was 'lying on his front' in the mud, like the Edenic serpent, and sported the traditional devilish red beard. With delicate flirtation she even attempts to enquire whether he is indeed that poacher, or one who would behave similarly: 'Have you ever...stopped a woman?' (*P1* 176) She shifts on from flirtation, mopping his brow and cheek with her chiffon, to a request for seduction ('Tell me about love. Speak to me of love' (*P1* 176)), to actually undressing and manhandling him:

And what have you got under your jersey? Let's see. (*Slight pause.*) I'm not tickling you am I? No. Good...Lord, is this a vest? That's quite original. Quite original. [*She sits on the arm of his chair.*] Hmmm, you're a solid old boy, I must say. Not at all like jelly. (P1 176)

So, rejecting her husband by specific reference to his jealous description of the man as 'a great bullockfat of jelly', Flora quite explicitly offers herself to the matchseller, throwing her arms around him and suggesting she give him a good scrub in the bath. To underscore her adoption of him, she gives him a name: Barnabas. The previous allusions to original sin and Flora's rape 'long before the flood' seem to invite here yet another biblical reference; but if Barnabas is, by its similarity to Barabas, an allusion to the thief who was chosen instead of the condemned Christ, then the analogy barely holds water. Edward's attitudes and afflictions can only partially dress him as a representative of all humanity – though his existential craving for recognition and self-affirmation does lend him some weight in that direction. This kind of clumsy allusion opens the gate to all sorts of symbolic interpretations, and can only weaken the impact of the play by directing it down too specific channels. It is this kind of over-explicitness that causes Simon Trussler to reject *A Slight Ache* as 'all symbol and no substance, with quite a few footnotes thrown in to make up weight'.[13]

Clearly, issues of gender held metaphoric potential for Pinter, but these were never perhaps fully integrated or resolved in the manner in which he sought to pursue them in his earlier works. Releasing his female characters from the allegorical structures he originally sought to constitute, and examining them as motivated individuals in antagonistic interaction with his male characters in a collection of plays from the early sixties, he was able more effectively to interrogate the nature and ramifications of male attitudes towards femininity.

GENDERED INVASIONS

When Pinter was asked in 1963 by the Grove Press in the States for a contribution to a film project involving additional scripts from Samuel Beckett and Eugène Ionesco, he prepared a screenplay entitled *The Compartment*. The project faltered and

the work remained unfilmed and in 1966 he rewrote it, as *The Basement*, for BBC television. At first glance this work is an adaptation and development of *Kullus*, Pinter's short prose work from 1949. The significant difference is the inclusion of a female character, and the potent combination of sexual rivalry with territorial ambition. Like the invading character of Kullus, Charles Stott turns up one rainy night at his friend Tim Law's apartment with a young girl, Jane, in tow. They are welcomed by Law but immediately behave as though his home were their own, undressing and making love in his bed. At first their encroachment is one of polite suggestion, as Stott walks around the room turning off Law's lamps, but eventually it moves from more insistent persuasion (his removal of Law's collection of watercolours) to actual refurbishment and redecoration so that the room appears 'unrecognizable' (*P3* 153). In *Kullus*, following Kullus's invasion and impositions, the narrating figure admits that 'I am no longer in my room' (*VV* 77). Similarly, the visual effect of seeing Law's 'comfortable, relaxed, heavily furnished' room (*P3* 143) transformed to a lighter, sparser apartment with modern Scandinavian furniture, parquet flooring and an Indian rug suggests beyond doubt that we are no longer in Law's room.

The technique is one Pinter had applied earlier in his 1962 screen adaptation of Robin Maugham's short story *The Servant*, in which the aristocratic Tony employs the wily manservant Barrett and slowly becomes psychologically and emotionally dependent upon him as the power dynamic between them is gradually defined. In the novel, Maugham has Tony rent a furnished house, but Pinter's opening sequence presents an unfurnished, seemingly unoccupied home. Symbolic as this might be of Tony's weakness of character, or his emotional and moral vacuity, it also provides Pinter with the opportunity to indicate visually the gradual stamp of authority that Barrett applies to the home the two men share. Like Kullus and Stott, Barrett draws curtains during daylight hours and removes, obscures or adjusts his host's decorations. Tellingly, once Barrett is re-employed following a sacking for using Tony's bed for sex, the home is metamorphosed:

> There is an overlay of BARRETT everywhere. Photos of footballers cellotaped to mirrors. Pornographic calendars. Nudes stuck in oil paintings. The furniture has subtly changed, the rooms no longer possess composition.[14]

A room transformed by an invading occupant is also a motif that appeared in another TV play, *Night School* (1960), in which failed counterfeiter Walter returns to live with his two aunts after a brief stint in jail, only to discover they have let out his room to a mysterious young woman. Clearly, as Pinter grew as a writer he continued to develop his interest in the representative value of rooms as personal sanctuaries, refuges that separated familial groups from social groups or that protected 'self' from 'other'. But whereas Davies (*The Caretaker*), Goldberg and McCann (*The Birthday Party*), Riley (*The Room*) and the silent witnesses of the eponymous dumb waiter and the matchseller (*A Slight Ache*) were all invaders that undermined and unsettled, Pinter began to create intruders who actively sought to transform domestic environments and, by extension, redefine or challenge those who occupied them. This pattern is true to some extent of many of his dramas of the early sixties, including *The Basement*, *Night School*, *The Collection* and *The Homecoming*. The significant difference between the invasions that operate in these works and those of Pinter's work in the late fifties is the specifically gender-based agendas that are brought to the fore. There is also a notable shift to a more realistic mode of writing, away from seemingly allegorical models. In *The Room*, *The Birthday Party*, *The Dumb Waiter* and *A Slight Ache*, issues of gender were subordinate to (or embroiled within) more general concerns of threatened identity and displacement, and the angst and confusion that confrontation with those threats caused. With his plays, screenplays and writing for television in the sixties, however, Pinter pursued more directly a distinct interest in the structures of sexual relationships.

This concern was first signalled in the character of Virginia in Pinter's 1950s novel *The Dwarfs*. Her romantic affairs with two close friends, Pete and Mark, accelerate the deterioration of the relationship between the two characters, and it is the interference of her femininity with the male bond between the other characters that informs one of the novel's key movements. Pinter contrasts the virginal overtones in her name with Pete's boozy abbreviation of it to 'Ginny', thereby accentuating a certain male perception of feminine duality – simultaneously pure and debased – that was to become characteristic of the representation of many subsequent female roles. At first Pete is

comfortable with the essentially platonic relationship he holds with Virginia and is untroubled by the infrequency of their lovemaking. He explains that his attraction to her is based on her rejection of the traditional paraphernalia of feminine attraction, such as jewellery and make-up. And yet when she dares to extend this platonic framework into Pete's fraternity of acquaintances (by offering an opinion on *Hamlet* into a conversation between himself, Len and Mark), he is horrified. His subsequent verbal offensive not only serves to put her in her perceived intellectual place, but is combined with an attack on her sexuality by berating her for exposing herself to him in her untied dressing-gown. At her following appearance she is silently domestic, providing tea for the men and doing the washing-up. She later requests a fortnight's reprieve from their relationship, chooses not to return to him, and, now wearing lipstick, befriends a seedier Soho crowd. When Mark attempts to contact her, they end up making love, and Virginia reveals that Pete thinks he is a fool. This precipitates a confrontation between the two friends which extends over twelve pages, and inevitably concludes with the termination of their friendship.

The dwarfs of the title are the diminutive helpers and taskmasters that Pete and Mark's mutual friend, the schizophrenic Len, believes inhabit his flat and yard. Providing an adequate parallel for the need to deal with unvocalized animosity, Len's condition was probably considered adequate to convey and support the themes of emotional entropy and betrayal in the radio and stage adaptations of the novel, in which the character of Virginia does not feature. In these, it is he who informs Mark of Pete's assessment of him as a fool. But what the novel portrays successfully is the intrusion of a female presence into an exclusively male clique, serving as a catalyst to expose considerable personality flaws and interpersonal game-playing.

Virginia's plight in *The Dwarfs* is an unhappy one, and Pinter is perhaps guilty of leaving her to her fate once she has played her role in his narrative. She is nevertheless sympathetically portrayed, maintains substantial dignity and is blameless for her part in an inevitable rift between friends. This seems to be more or less the case with many of Pinter's women who are seen to bring about similar disruption within the sacrosanct world of male union. They might be castigated by the men involved, and

often fall short as representations of women, but their inclusion in Pinter's fictions usually only serves to reveal male weaknesses. *The Basement* might certainly be viewed in these terms. Stott's Lolita-esque girlfriend, Jane, becomes the subject of Law's carnal fantasies and the drama dissolves into a competition between the two men, presumably for her favours. She is perceived not simply as a sex object, but as a betrayer of men, 'a savage. A viper' (*P3* 158). Law's attempt to turn his old friend against her is in part an attempt to distance himself from the temptations of his fantasies, but also a veiled call for male solidarity. The mythologizing of the male bond is active in much of Pinter's writing and is perhaps central to an understanding of his portrayal of women. Pete in *The Dwarfs* declares that male friendship might 'constitute a church, of a kind' (*TD* 55) and we revisit that almost dogmatic view either implicitly in plays such as *The Collection* and *No Man's Land* or explicitly in others such as *Monologue* and *Betrayal*. In this latter play, Robert refuses point-blank to have his wife intrude into the sacrosanct male-bonding rituals that surround a game of squash:

> You don't actually want a woman within a mile of the place, any of the places, really. You don't want her in the squash court, you don't want her in the shower, or the pub, or the restaurant. You see at lunch you want to talk about squash, or cricket, or books, or even women, with your friend, and be able to warm to your theme without fear of improper interruption. (*P4* 57)

While the presence of female characters in *The Dwarfs*, *The Basement*, *The Collection* and *Night School* seemed to serve as foils or instruments by which to reflect or analyse the characteristics of distinctly male interaction, other works of the period saw Pinter widening his focus and commenting more directly upon the nature of emotional and psychological interaction between the sexes. The perspective in operation, however, was undeniably male, and television plays such as *A Night Out* (1959), *The Lover* (1962) and *Tea Party* (1963) provided little in the way of fully rounded or sympathetic female roles. These plays exploited in their dramatic structures the essentially demeaning, male-identified images of women as personas to be desired, feared or respected and it is the manners in which the male characters adopt these one-dimensional perspectives, and the strategies

they employ for reconciling different perspectives applied to the same women, that drive the intriguing developments of these works. For example, in *The Lover*, the character of Richard seeks to assuage his perceived contradictory needs for a woman he could 'admire and love [. . .] a woman of grace, elegance, wit, imagination' (*P2* 170) and 'someone who could express and engender lust with all lust's cunning' (*P2* 157), and this he does by steadily coercing his wife, Sarah, into simultaneously embracing the role of whore as well as that of dignified suburban partner. Similarly, Disson in *Tea Party*, the manager of a successful sanitation installation business built up from humble beginnings, seems incapable of relating to women as anything other than objects to be either revered or coveted. We first meet him as he interviews his new secretary Wendy and learn in the course of their conversation that he is getting married the following day. His drama begins, then, with his simultaneous acquisition of a woman both in the home and in the workplace. Televisual close-ups of Wendy's crossing legs as she recounts the details of the unwanted attentions of her previous employer establish her quickly, from Disson's perspective, as sexual object. Disson's wife Diana, by contrast, is portrayed as the 'ideal' wifely figure:

> Par excellence as a woman with a needle, beyond excellence as a woman of taste, discernment, sensibility and imagination. (*P3* 101)

The subsequent action of the drama charts Disson's gradual breakdown as he seeks to reconcile the conflicting impulses of retaining the dignity of his familial and social position and consummating his sexual urges. The impossibility of simultaneously appeasing these two needs is the apparent cause of his breakdown, which is signalled to us by incidences of paranoia and an inexplicable fault with his otherwise twenty-twenty eyesight. But while Disson tries, and fails, to separate his different emotional and erotic impulses, Richard in *The Lover* goes some way towards taking control of that breach by questioning and subverting a well-established marital love-ritual in which, once he leaves home for the office each morning, he returns during the afternoons as his alter-ego, Max, to act as his wife's lover. He insists, however, that Sarah's debauched afternoons must come to an end and claims to have paid off

the whore who figured in his side of the fantasy. If his intentions are the re-establishment of a 'normal' pattern of behaviour the play might end there, but it becomes apparent that he means to break down the closeted distinctions between their platonic and erotic interaction, and merge the two into one. His subsequent breaking of the rules of their 'arrangement' and bringing their drum, the catalyst of their erotic interplay, out of its cupboard in the evening and then initiating their role-play as himself (and not as Max) both indicate as much. We sense that the drama is resolved once Richard gains control, but this is somewhat dissatisfying dramatically in that no true balance has been achieved, as Sarah must now administer to his needs instead of his facilitating her fantasies.

Tea Party is more satisfying in the manner in which the merging of social and sexual concerns provides a more sophisticated experience. The drama operates by exposing its viewers to the convergence of a collection of irreconcilable dichotomies, the varying thematic strands (business, whore and lower-class consciousness all contrasting with domesticity, wife and upper-class pretensions) merging into one whole dramatic progression. Having married into a higher class, Disson's social and sexual anxieties are united and intensified by the rivalry that develops when he takes his wife's brother, Willy, as his business partner. Willy immediately employs Diana (Disson's wife) as his secretary, effectively bringing the home into the office. Disson would clearly prefer distinctions between the two domains to remain clear-cut, and maintains the traditional stance of seeing no reason for a wife to work. This is in accordance with his stated belief that

> I don't like indulgence. I don't like self-doubt. I don't like fuzziness. I like clarity. Clear intention. Precise execution. (*P3* 105)

It seems, however, that everything is conspiring against this ethic, and dissolution of his world is the inevitable outcome. When Willy requests Wendy's services, Disson finds his refuge in sexual fantasy being encroached upon too, and the paranoiac tics we have seen in him so far (his annoyance at his children's whispering, for example) accelerate his loss of control. The prose version captures the power of this paranoia admirably:

With my eye at the keyhole I hear goosing, the squeak of them. The slit is black, only the sliding gussle on my drum, the hiss and flap of their bliss. The room sits on my head, my skull creased on the brass and loathsome handle I dare not twist. For fear of seeing black screech and scrape of my secretary writhing blind in my partner's paunch and jungle. (*VV* 90)

The adverbial use of 'blind' here is telling. It not only bonds sightlessness and passion, but, through the implied lack of visual verification of events, it partially relinquishes Disson's guilt by projecting his own desired behaviour outward onto his phallicly named brother-in-law, whilst all the time inflaming his anxiety through the distinct blindness of paranoia. Already in the drama, sightlessness and passion have been connected in a prop – Wendy's chiffon scarf that Disson has her tie around his eyes. This is fetishistic behaviour; activity that permits the release of desires otherwise held in check by convention. It also signals Disson's withdrawal from a reality over which he no longer has control. When, in the final scene, the camera provides a number of views of the tea party from 'Disson's point of view' (*P3* 137), despite his blindfold, we are being invited to share his fantasies through close-ups and shifting perspectives, and our confusion is merged with his. Sporting the bandages provided by his friend and doctor, he has evidently managed to distance himself from Wendy, and now interprets the noises he hears as the ultimate projections of his paranoia. The conspiracy he has detected between his wife, brother-in-law and Wendy reaches its climax with Wendy's acceptance of Diana and Willy's offer to join them on holiday, and this is immediately translated visually by Disson into incestuous and orgiastic behaviour, instigating his final collapse:

> WILLY *puts one arm around* WENDY, *the other around* DIANA.
> *He leads them to* WENDY's *desk.*
> WILLY *places cushions on the desk.*
> DIANA *and* WENDY, *giggling silently, hoist themselves up on to the desk. They lie head to toe.*
> DISSON's *point of view. Close-up.*
> WENDY's *face.* WILLY's *fingers caressing it.* DIANA's *shoes in background.*
>
> (*P3* 137)

It is the suggestion of incest that seems to indicate the impossibility of these visions as being anything other than

fantasy, the painful projections of personal conflicts that Disson has failed to reconcile.

Ronald Knowles relates Disson to both Edward (*A Slight Ache*) and Goldberg (*The Birthday Party*),[15] both of whom also suffer breakdowns as a result of the undermining of the authoritative structures that define their existences. This pattern is revealing in that it indicates once more an essentially political undercurrent to Pinter's early writing, and *Tea Party* is certainly as successful as a social commentary as it is anything else. In her assessment of Disson's breakdown, Katherine Burkman also mentions *A Slight Ache* and *The Birthday Party*, but from the perspective of the similar ritual structures they and *Tea Party* seem to employ.[16] The difference, here, is in how an audience might relate to the plights of each play's protagonists. Whereas Stanley is a clear victim, blindfolded at his own ritualized birthday party, organized against his will, Disson chooses both the party and the blindfold. It is a strategy of coping with irrepressible urges, perhaps. Unlike poor Stanley, we do not see the consequences of Disson's breakdown. His 'eyes open' (*P3* 139) catatonic stare in the closing sequence suggests, though, that he has failed in his attempt to control the confrontation. Unlike Edward in *A Slight Ache*, who talks himself into oblivion, Disson lacks the self-awareness that might offer salvation.

Albert in *A Night Out* is another character who fails either to escape his own restrictive perceptions of women or achieve anything like self-awareness. He is presented as the victim of an overbearing mother and this partially acts as a microcosm of the social forces of constraint and entrapment that inform his existence: the oppressive notion of 'breeding' that is reiterated throughout the play. Effectively the three acts (of the published stage version) offer three perspectives on Albert's interaction with women – all of which are informed by his inability to shake off the oppressive but comfortable relationship he has with his mother. We see the domestic, the social and the interpersonal strategies Albert employs catalogued in each of the three acts. The first shows us his gentle negotiations for freedom pitted against his mother's tactical assault of emotional bribery and armoury of guilt-inducing refrains ('put a bulb in Grandma's room', 'what about your dinner' (*P1* 333 and 334)). We witness an excessively restrictive structure of nurturing, one that has

stagnated as though time has stood still and Albert were still a boy. Mrs Stokes's insistence on referring to Grandma's room (when grandma is ten years dead) and using the present tense to invoke her deceased husband are characteristic of this. The use of a clock, later, as a weapon of revolt is not insignificant. Clearly, it is apparent that the growth of Albert's social self has been stunted, and the play is to chart the events that lead up to his self-revelation and consequent self-assertion. Albert is, however, ill-equipped to deal with the social engagement of a works party for which he is preparing, and one detects more than a hint of truth in his comforting his mother with 'I'd much rather stay with you' (P1 334). The second act shows us his application of avoidance tactics, as he attempts to escape the attentions of Joyce and Eileen. His being accused later of 'taking a liberty' with Eileen is ironic as he patently is no more capable of making such an advance than he is of standing up to his mother. The third act, though, does not just demonstrate Albert's incompetence on the interpersonal level, the opportunity to develop such skills never having been available to him; his confrontation with the prostitute in her flat also acts as a synthesis to the thesis and antithesis of the first two acts. In the Girl, he is faced with the embodiment of the female stereotypes/archetypes and his stunted personal development prevents him from seeing beyond these. She is at once a mother (so she claims), and nags him like his own, a whore, for prostitution is evidently her profession, and a wife figure – that is to say she professes to a level of dignity and breeding that would beggar a respect denied by her activities. Indeed, Pinter's portrayal of the Girl is not entirely without dignity, although it does seem that such attributes are set up as an Aunt Sally for Albert's ruthlessly exposing assault. He tears the photo of her daughter from its frame only to reveal that it is in fact a picture of the woman herself, as a young girl. Aware of her falsity, he perceives her as a duplicitous part of a general female conspiracy against him:

> You're all the same, you see, you're all the same, you're just a dead weight around my neck (P1 371).

This summation of his anger and frustration that evening is levelled at the women with whom he has had dealings; there is no mention here of the bullying he suffered at the hands of his

workmate Gidney at the party. His humiliation of the Girl represents not only a release from, but a maturation (as Freud might have it) beyond his passive or fearful response to femininity. Once back at home, however, the joy he displays at his new-found confidence ('*he yawns luxuriously, scratches his head with both hands and stares ruminatively at the ceiling, a smile on his face*' (P1 374)) is soon sapped from him by his mother simply calling his name: '*His body freezes. His gaze comes down. His legs slowly come together. He looks in front of him*' (P1 374). His final trance-like posture, along with this mother's words, demonstrates the ultimate impossibility of escape, of personal development. Mrs Stokes's closing monologue, merging reproach into forgiveness, ends with the soothing reiteration of her son's return to the status quo:

> You're not bad, you're good...you're not a bad boy, Albert, I know you're not...[*Pause*] You're good, you're not bad, you're a good boy...I know you are. (P1 375)

Reaching an audience of 16 million people in ABC TV's 'Armchair Theatre' on 24 April 1960,[17] *A Night Out* was arguably Pinter's first truly popular success and the first real step in his becoming a household name in Britain. As a piece of popular writing, it succeeds primarily as entertainment rather than as enriching or edifying drama. Ultimately, the play presents no defence against any charges of misogyny that might be levelled at it, although it hardly reinforces stereotypical masculine traits and, in the end, our sympathy for Albert is significantly qualified. When the Girl tells Albert that his face is childlike and 'almost retarded' (P1 369) we, in our despair for him, tend to agree with her. Our assessment, though, is not simply of his appearance, but of his maturity. His inability to confront his mother with anything other than violence has caused him to lose a good share of our sympathy. Consequently, it is not possible for an audience to share in his petty triumph over the Girl, and if we pity Albert in the final physical capitulation he makes to his mother's voice, it is not so much because he is the victim of oppression, but because he has failed to find a caring strategy for absorbing or combating its root cause.

The television plays *A Night Out*, *The Lover* and *Tea Party*, then, each demonstrate the pitfalls of masculine urges to categorize

women as mothers (protecting, domineering), wives (pure, submissive) or whores (sexually promiscuous, degraded). The dramatic success of such works must rely upon a breadth of recognition within an audience that such emotional, social or inter-sexual structures have any currency. Their value as 'truths', worthy of dramatic inspection and questioning, might have been more valid in the Britain of the early sixties, when gender roles were more distinctly drawn in the home, society and in the workplace, before the social, cultural and sexual revolutions of the oncoming decade. The vocabulary, as it were, has become more transparent and consequently more vulnerable to greater critical attention. Pinter's interest, though, lay in the power shifts and negotiations that these archetypal structures facilitated for drama, and in the very human contradictions to which male emotional needs were exposed when confronted by such easily reducible models of femininity. The failure of Richard, Disson or Albert adequately to quantify femininity and achieve a whole and integrated appreciation of women folds in on these male characters, as they fail equally to come to terms with their own identities.

If the wife/mother/whore triumvirate was an early obsession of Pinter's, it reaches its apotheosis in the character of Ruth in *The Homecoming*. She is introduced by her husband to his brothers and father, only to accept their offer of staying with them as a shared lover and maternal house-maker, earning her keep by embracing a position as a local prostitute. *The Homecoming* also represents the culmination of the phase in Pinter's writing, only finally properly exorcised with *Old Times* (1970), in which he had been concerned with territorial struggles, indefinable external menace and masculine anxiety in confrontation with femininity.

An audacious play that never ceases to shock audiences, *The Homecoming* is considered one of Pinter's finest. Though the play does not address sexual politics from any moral standpoint, it generates all of its drama by examining the interaction of a set of established attitudes to women with a woman who challenges those attitudes by taking control of the factors (male physical and emotional needs) which inform them. Though ostensibly the homecoming is Teddy's, visiting his family during a holiday out from his academic career in America, the shape of the play

builds towards Ruth's acceptance of a place in his family's all-male household, filling the hole left by the death of Max's wife Jessie. It is the homecoming of the wife and mother figure, the home-maker and provider of sexual stimulation. The gap left by Jessie is physically represented on-stage by 'a square arch shape' (*P3* 14) in the back wall of the living room in which the action takes place. Teddy associates the restructuring of the house with the death of his mother, implicitly forging the connection in an audience's minds. Before he introduces us to Ruth, however, Pinter first establishes the language of interaction and the currencies of negotiation which operate within this household.

We are introduced to the family one by one, as Max, Sam and Joey enter in quick succession to join Lenny in the living room of a large North London house. Each of their places in the family are quickly made quite plain through expositional references to kinship, and some of their background is revealed through Max's reminiscences. Significantly, we learn that Max's wife, spoken of in the past tense, is dead and that his relationship with her could at best be described as ambivalent:

> Even though it made me sick just to look at her rotten stinking face, she wasn't such a bad bitch. (*P3* 17)

This ambivalence, which simultaneously applies contradictory veneration and hatred of women, is introduced to us as a key factor in the outlook of this male collective. Max's use throughout the play of gendered insults such as 'bitch', 'tit' and 'slag' is typical of this attitude. These words in themselves are not only demeaning of women, they also actuate a further abasement of women in Max's application of them to slur the male members of his family. As well as firmly establishing the misogynistic tone, such vocabulary is also typical of the linguistic distancing that the characters place between their words and their emotional being. We soon appreciate that their verbal interaction is a process of mockery and defence, of belittling one another in a shifting game of power advantage. When, in the play's opening moments, Lenny can't get his father to 'shut up' or 'plug it' by calling him a 'daft prat', a 'stupid sod' or 'demented' (*P3* 15 and 17), he reaches for this tactic, firstly by undermining his father's expert opinion over a racehorse and secondly by ridiculing the old man's cooking. When he

successfully riles Max, he cowers in mock terror at his father's rising anger and threatened use of his walking stick. The individual's superiority is thus achieved through the application of mockery, the countering of any defence, and the reduction of the victim to outbursts or threats of violence. When Max attempts to do the same by teasing Sam he fails because his brother refuses to rise to the bait, and only ends up annoyed once more himself.

Max's condition is one of denial. He cannot accept his weakening grip on authority and easily lashes out at dissenting or disrespectful voices. As father of his brood and cook of the house, he represents both parents in one and his violent rages and threats are his way of demanding the respect due to both mother and father. His initial annoyance with Lenny, and later with Sam and Joey, stems from their demands for food and criticisms of his ability to provide it. 'Go and find yourself a mother' (P3 24), he complains to them all, effectively acknowledging his emasculating position in their ménage. And yet we glean quite quickly that Max is more than reconciled to a traditionally female role. The kitchen, for example, has become so much his domain that he does not feel comfortable anywhere else and resents Sam's disruptive presence there. Later we learn that his identification with the maternal role pre-dates his wife's death, in that it was he who would bathe their children and tuck them into bed. When he is finally over his surprise at Teddy's reappearance, he reverts to this earlier play of affection and suggests that they share 'a nice cuddle and kiss' (P3 51). This contrasts with the harsh assertive masculinity of a man who would apply the vocabulary of his former butcher's trade by way of threat: 'I'll chop your spine off' (P3 17), 'You'll drown in your own blood' (P3 44).

As an audience, we are naturally sympathetic towards Ruth when she first enters what we can only imagine will be a hostile environment for her. But after the initial misgivings and reluctance she vocalizes, she soon establishes herself as an uncontrollable force, first by refusing to go to bed as Teddy suggests and then, taking the key from him, going out for some air and leaving him to retire alone. Her presence in the house is at first an immediately disruptive one. When alone with Teddy's brother, Lenny, he seems at first to ignore as incredible her claim

to be his brother's wife ('You sort of live with him over there, do you?' (*P3* 37)) and instinctively makes a sexual advance: 'Do you mind if I hold your hand?' (*P3* 38). When Ruth asks why he might want to do that he simply reels off two anecdotes that imply his brutal domination over women, indicating that access to her sexuality is his innate right. But she represents an effective challenge to him, shrugging off his threatening postures and out-manoeuvring him verbally by adopting assertively maternal and sexual postures:

> LENNY. [...] I'll relieve you of your glass.
> RUTH. I haven't quite finished.
> LENNY. You've consumed quite enough, in my opinion.
> RUTH. No, I haven't.
> LENNY. Quite sufficient, in my own opinion.
> RUTH. Not in mine, Leonard.
> *Pause.*
> LENNY. Don't call me that, please.
> RUTH. Why not?
> LENNY. That's the name my mother gave me. *Pause.* Just give me the glass.
> RUTH. No.
> *Pause.*
> LENNY. I'll take it, then.
> RUTH. If you take the glass ... I'll take you.
> *Pause.*
> LENNY. How about me taking the glass without you taking me?
> RUTH. Why don't I just take you?
>
> (*P3* 41–2)

That Lenny is disarmed, and that Ruth is one step ahead of him, is indicated to an audience by the pauses that follow each of her unexpected assertions. Later, when the family is gathered around Ruth and Teddy, she once more cuts Lenny up by interrupting his mocking attempt to provoke his brother with pseudo-philosophical enquiries and making the scene-stopping declaration:

> I move my leg. That's all it is. But I wear ... underwear ... which moves with me ... it ... captures your attention [...] My lips move. Why don't you restrict your observations to that? (*P3* 60–1)

The attention this announcement commands is so intense that it clears the room. In drawing attention to her sexuality, or rather

the objectification of her sexuality, she is emphasizing her awareness of its potency. By now represented as both a wife and mother, she is also sending confusing signals to this group of men. Teddy is aware of the dangers he has unleashed and immediately decides that it would be best to return home. He knows that the powder-keg is constructed of a specific ideology and detects that Ruth is lighting matches with her cunning proficiency at articulating its vocabulary. This family ideology permits a wife to represent concurrently both aspects of a perceived female duality, deserving either the respect due to a mother, or the scorn due to a whore. This is the male Achilles' heel from which Ruth patently seeks to profit. The deceased Jessie is remembered, for example, as both a woman with 'a heart of gold and a mind' (P3 54) and 'a slutbitch of a wife' (P3 55). This contradictory response to womanhood colours the manner in which Ruth is initially greeted by Max when she and Teddy make their appearance the morning after their arrival. Ignorant that his distant son is married, his outraged assumption is that Teddy has brought a 'stinking pox-ridden slut' (P3 49) into the house. Once he is convinced of the truth, however, Ruth is considered 'a nice feminine girl with proper credentials' (P3 57) and 'an intelligent and sympathetic woman' (P3 59).

Significantly, though, Teddy, seems to refer to women with the same binary biases as his family and one might strongly question his motivation in bringing his surprise wife home, as some sort of trophy to reveal to them. When they first arrive on-stage his treatment of her is condescending in part, and when later she reveals to his family that she was 'different' when she first met Teddy he quickly butts in to reassure them that she is 'a wonderful wife and mother' (P3 58). Her eventual revelation that she once worked as a 'photographic model for the body' (P3 65) – possibly a euphemistic way of describing a career in pornography – reveals a sexuality that her marriage and children have now concealed or denied. If, as would seem apparent, Teddy has found a woman that first matched the libidinous image of femininity and carefully forged her into one that matched the maternal image, he has behaved totally in accord with his family's prejudices. By polarizing aspects of Ruth's femininity, he has sought to avoid the conflicts that female duality has manifested in his family, but this has been at

his wife's expense. When Ruth bemoans America as a place of rock, sand and insects, she capably projects that aridity back on her marriage, and suggests her imminent struggle for release. Teddy might have believed that by going abroad he was escaping the domination of an ideology that belittles him in the way it both denigrates and venerates the women he relies upon for emotional sustenance, but his gloating return has only re-initiated an irrepressible cycle.

Max is aware of the danger of this cycle repeating and declares that each generation will be the same as the last: 'One cast-iron bunch of crap after another' (P3 27). He attempts to impress upon his family that Ruth will 'do the dirty on us [...] she'll make use of us' (P3 89) and recognizes that, though a woman might again provide the family with a focus, she will subjugate them all and provide for untrustworthy satiation of their desires. 'Fillies are more highly strung than the colts, they're more unreliable' (P3 18), he points out early on, and attempts to stare Ruth out in the way he would stare out a horse to see if she was a 'stayer'. Ruth's potential success in exploiting the family's confusion at complex femininity is prefigured in the character of Jessie, who dictated 'every single bit of the moral code they live by' (P3 54). The information that Max's wife was unfaithful with his best friend MacGregor in the back of Sam's car not only confirms the various suggestions that the mother figure was less than reputable, it more significantly indicates that, like Ruth, she had an agenda that did not hold the concerns of the men as its focus. Perhaps Max's earlier outburst, 'I've never had a whore under this roof before. Ever since your mother died' (P3 50), could now be taken literally, explaining why, in a world-view that regards mother and whore as mutually exclusive female roles, Max was the one who took on the servile, domestic responsibilities. When Lenny taunts his father by asking for the details of his own conception, he is consciously disrupting this binary perception of women in his father, and also hinting at his awareness of his own potential illegitimate status. Sam's revelation to Teddy that he was Jessie's favourite son might also imply that Max's complaint of having 'three bastard sons' (P3 55) might actually be taken literally. This would mean that this 'family' consisted of a group of men with no male genealogy between them, but who are bound only by their

blood relationship with one woman. In this respect, the final tableau represents the re-establishment of that missing connection: a powerful matriarch who threatens domination, but who is irresistible in the promise to assuage physical and emotional needs.

Arguably, Ruth might be considered as a victim of male obsession as, from the male perspective, she is transformed and degraded from a wife, to a sexual object, to a whore. And yet, she might also be considered to have effected a liberating transformation from an object of male desire (a photographic model) to a wife, to an independent being who exerts her own control on those who would manipulate her. The manner in which Ruth is seemingly empowered by her ability to play the game better than the men who make the rules sets her apart as one of the first of Pinter's women to escape the archetypal responses to womanhood that his male characters often project. Nevertheless, the debate as to whether the play confirms or challenges male constructions of female identity rightly continues with each new performance. Certainly, the feeble truism that women can become independent by manipulating men and playing them at their own game is not an adequate response to patriarchal models. Michael Billington's view that *The Homecoming* is an 'implicitly feminist play'[18] seems somewhat overstated, given the varied spectrum of attitudes and perspectives that the term 'feminist' implies. The reduction of femininity to mother, wife or whore is, after all, a simplification that reflects a predominantly masculine psychology. With *The Homecoming*, however, there is a meaningful shift towards what Elizabeth Sakellaridou defines as an androgynous authorial viewpoint.[19] In Ruth, Pinter created a woman who succeeds in exceeding the limiting delineations of femininity that the male characters attempt to impose. She thereby comes across as the first credible, multidimensional female character of his dramatic writings.

Prior to *The Homecoming*, as has been seen, there had been thematic conflicts in Pinter's work whereby the issue of sexuality had obscured or weakened the impact of otherwise existential, asexual concerns, limiting the ultimate communicability of the dramatic force by offering a uniquely male perspective. This essentially psychological reality arguably interferes with the metaphoric communicability of plays such

as *The Room* and *A Slight Ache,* and any meaningful function they might possess from a female perspective must depend upon the degree to which the individual spectator might recognize the male urge/necessity to categorize women, and her own complicity or discomfort with that categorization. The recognition need not be conscious (our ability to recognize social or psychological reasons for the identifications we make when enjoying drama are anyway subdued) but it is likely that the degrees of conscious or subconscious complicity and discomfort with male stereotyping are likely to be far more varied in the female members of an audience than in their male counterparts. What *The Homecoming* perhaps actualizes in any male member of its audience is an awareness of how his tendencies to perceive women emotionally and physically might serve as extensions of his own personality. As these concerns form the dominant dramatic vocabulary of motivation and exchange, the empathic bond between Ruth and the female members of an audience is less likely to be so universally experienced, and might depend upon the interpretations applied by actors and directors of each specific production. Whatever connections are struck, audience members of *The Homecoming* are inevitably placed in a position where they have to reconcile their recognition of specific attitudes with their personal responses to those attitudes, and this is part of the play's dramatic effectiveness.

Tragedies of Isolation and Belonging

BRIDGING THE SILENCES

> The past is a foreign country. They do things differently there.[1]

The first words of L. P. Hartley's novel *The Go-Between*, adapted for the screen by Harold Pinter in 1969, this statement seems a fitting frontispiece to much of Pinter's writing between 1967 and 1982.

Artistically inclined against voice-overs in film, Pinter resolved to reduce the first-person narrative of that novel by constructing an accumulation of remembrances where visual and aural materials from past and present merged. In this way, he managed effectively to portray the novel's concerns with how the emotions and experiences of the past can form one's present-day experience. He had admired the work since its appearance in 1953 and had considered a screen adaptation of it for some years (a first attempt had been made in 1964), it is tempting to infer that its themes represented a significant component of a new creative impetus for Pinter, one that drew him into contemplating the force of memory as an ineluctable constituent of our daily emotional being. It was an impetus that was stimulated and was further impassioned by such activities as his directing James Joyce's *Exiles* at the Mermaid Theatre in 1970 – a play about the ethical and social evolution away from the moral codes of the past – and his ambitious screen adaptation in 1972 of Marcel Proust's *À la Recherche du temps perdu*, an epic statement about the past's relationship with the

present. Having thoroughly pursued menace and the potential violences of interpersonal relationships, peaking in 1964 with the domestic, sexual, social and psychological tensions generated within *The Homecoming*, Pinter had found a new voice with which to craft new formalistic structures and shed fresh dramatic light on some of his key concerns. By articulating theatrically the impenetrability of the past and the inconsistencies of memory, he found he could continue to explore the complex nature of domesticity and the multiple dilemmas that abound in male/female relationships. To do this involved combining potent visual motifs (both seen on-stage and evoked verbally) with the auditory qualities of a lyricism paced by scaffolds of pauses and silences.

> Objects intercepting the light cast shadows. Shadow is deprivation of light. The shape of the shadow is determined by that of the object. But not always. Not always directly. Sometimes it is only indirectly affected by it. Sometimes the cause of the shadow cannot be found. (*P3* 186)

These are some of 'the basic principles of drawing' that the character of Beth recalls in Pinter's *Landscape*, written in 1967. In the context of her daydreaming remembrance of a day spent on the beach with a lover, these principles take on poetic dimensions, for when Beth speaks of a shadow's shape being only indirectly affected by that of its causal object, or of shadows that have no cause, she is clearly no longer speaking simply of the principles of drawing. The objects that cast these memories are incidents, people and emotional states. Here, specific memories take on the characteristics of shadows; formless, shifting, intangible, like the images of a man and a woman that Beth remembers etching in sand which 'kept on slipping, mixing the contours' (*P3* 178). In this way Pinter articulates his own fascination with memory as a function of the emotive conscious mind, one that inexorably invades and defines the present moment.

Landscape was the first step Pinter took in this new direction, leaving his reputation for 'Comedies of Menace' behind him. We are no longer in a world of power manoeuvres punctuated by significant entrances and exits. This room is purposefully underemphasized ('the background of a sink, stove etc., and a

window, is dim' (P3 166)), and Pinter draws a clear focus with Beth in an armchair at one corner of a kitchen table and her husband Duff on a chair at the other corner. There is no movement from this tableau, aside perhaps from the occasional agitation that accompanies Duff's blighted attempts at conversation. In this way the *locus* of the drama is no longer that of a naturalistic setting, albeit that we see the play is set in the kitchen of a large country manor. By pulling an audience so intimately close to these two figures and by effectively reducing the shifts of dramatic focuses to nothing but their two faces, we are inevitably drawn into their worlds of remembrances. The play, then, takes place within these two minds, and, aided whenever possible by an intimate theatre space, we are irresistibly taken there, pleasurably captured by Beth's lyricism and Duff's chattiness.

The play is often described as two interwoven monologues that only tangentially intersect. Both Duff, in his early 50s, and Beth, in her late 40s, recount memories, but with clearly different objectives. From the onset, Duff is striving to engage his wife in conversation and speaks of his most recent dog-walking trip that took him through the park, by the pond, and later into a pub. He frequently addresses Beth and often attempts to solicit a direct response: 'Do you like me to talk to you?' he vainly enquires at one point (P3 179). She never replies, never looks at him, 'does not appear to hear his voice' (P3 166) and makes no allusion to his presence. Her own reminiscences (or fantasies) are of a much further distant time, of a day out with her lover on a beach and in a hotel bar, and of a morning when she washed the dishes and stood outside in the sun and mist. Staring out front, mentally recreating her past, this character is the more mesmeric of the two, and the vividness of her recollections and their emotional charge dismiss any petty naturalistic concern for why she is ignoring her husband. What we receive is the image of two emotionally distanced people; an image that is further illustrated by the contrasts contained in their memories. Duff speaks of a dismal, wet day with 'a lot of shit all over the place' (P3 170) and of sheltering from the rain under a tree. Beth remembers a warm day by the sea and, later, using a tree as shelter from the sun.

Yet, as with the echoed use of a tree in these memories, Beth's

words do seem occasionally to take the cue from Duff's. Her 'There wasn't a soul on the beach' comes immediately on the back of his 'There wasn't a soul in the park' (*P3* 171), and his talk of the pub seems to inspire her remembrance of the giggling girls in the hotel bar and her simple admiration for the act of having a drink bought for her. Most significantly, Duff's recollections of Mr Sykes (for whom they kept the house which they subsequently inherited) draws from Beth memories of specific times in his service. When Duff recalls a time when Mr Sykes entertained guests late into the evening at the end of which Beth joined him late to bed, Beth, minutes later, seems to provide a rejoinder: 'But I was up early. There was still plenty to be done and cleared up' (*P3* 183). She recalls that she was wearing the pretty blue dress Mr Sykes had bought her when, after clearing the washing-up, she shared a contemplative moment with the dog out in the early mist. Repeated references to the dress seem to deposit the suggestion that her late employer was in fact her remembered lover. Perhaps the most subtle of suggestions has been placed here; Beth came to bed so late that she woke Duff (had there been an amorous exchange between her and Sykes late that evening?) and then snatched time alone in the morning to brood in her gift dress, staring out of the kitchen window at children playing in the valley – in itself a return to the question 'Would you like a baby?' (*P3* 167) asked of her lover in the play's opening lines.

Perhaps Beth's recalled behaviour was in resigned response to Duff's confession of infidelity that he reminds her of. For him the recollection has significance because of the forgiving, tender, almost sensuous response he remembers her making. Supporting this, there is the suggestion that Beth's recollections are in fact of Duff: it is he who remembers her as 'grave' (*P3* 186) in her youth, an adjective Beth remembers being applied to her by her lover. Whatever interpretation is applied, this play is shaped by the emotional residue of some past circumstance that effected this couple's physical and mental separation. There is the briefest mention of an incident which might have been a symptom of some trauma that Beth suffered, the resonances of which might now still afflict this marriage. Duff recalls her banging the gong for lunch at a time when there was 'not a soul' to call and 'fuck all' to eat (*P3* 186). He remembers how in his

anger or exasperation he kicked the gong down the hall. The memory inspires in him a harsh, but emotionally desperate proposal of how he might have exacted the affection he is now denied by overpowering her 'in front of the dog, like a man, in the hall, on the stone, banging the gong' (P3 187). Perhaps this is also an articulation of the kind of oafish, two-dimensional masculinity that is at the root of this couple's distance. It is in stark contrast to her remembrance of (his or another's) lovemaking that then closes the play, and the contradiction leaves us with the deepest impression of the gulf between these two people:

> He lay above me and looked down at me. He supported my shoulder.
> *Pause.*
> So tender his touch on my neck. So softly his kiss on my cheek.
>
> (P3 187)

There is both gentle comedy and pathos created by the friction between Beth and Duff's two registers and sets of vocabulary, and the play's communicative power lies in this contrast. Their destinies interwound like their Shakespearean namesakes (Mac)Beth and (Mac)Duff, they seem equally irreconcilable, if considerably less violent, and it is the quality of this desperation that the play evokes. This Duff has been untimely ripped from his wife's affections and, reduced to solitary walks and idle chit-chat with strangers in pubs, he can do or say nothing to bridge the gap between a hopeless present and an idyllic or idealized past. This Beth is lost in that past, and its shifting contours are her only comfort. Seated and speaking together on-stage, they form a most compelling, tragic, dramatic metaphor, one that articulates the irrevocable truth that each of our lives is shaped by the ghosts of the past.

Censured by the Lord Chamberlain in 1967 for the inclusion of vulgar vocabulary, *Landscape* was eventually performed in a double bill with *Silence* at the Royal Shakespeare Company's Aldwych Theatre in 1969.[2] Completed earlier that year after a long writing period, the twenty-minute *Silence* was cast in a similar dramatic mould to *Landscape*. This time there are three characters: Ellen and Bates (roughly equating to the dreamy Beth and coarse Duff) and the kindly Rumsey (an incarnation of

Beth's gentle lover?). The play is set more firmly in the mental shifts of these three characters as now there is no naturalistic background to contain them. Instead, separated from one another, they each occupy a chair in 'three areas' (P3 190) and shift, as they speak, between present and past tenses. They each recall a time when they were caught in a virtually passionless love triangle: Ellen had loved Rumsey, an older man who exhorted her to find someone younger, causing her to settle for the not so much younger Bates. Another, further distant past is also recalled from which we glean that these three have known one another since Ellen was very little. Rumsey speaks of her having visited his country house as a girl, perhaps the same young girl that Bates remembers taking for a walk in the countryside. One such memory, recalled four times by Bates, seems thematically significant:

> It looked up at me and said, I see something in a tree, a shape, a shadow. It is leaning down. It is looking at us. (P3 198)

The image of this shadow, dismissed as a bird by Bates, has the force of Beth's shadow-memories, evoked here also by Rumsey's 'pleasant the ribs and tendons of cloud' (P3 193) that are 'sharp at first sight...then smudged...then lost...then glimpsed again...then gone' (P3 206). It is a shadow that bears down on each of these characters as they recall their unfulfilled desires and unrequited affections, the formless kernel of their past emotional inadequacies that shapes their present hollowness.

The fluidity of the applied lyricism and the varying distances in time that are casually jumped in *Silence* create an intriguing, temporally ambiguous theatrical world. The remembered days of their romantic liaisons were a time when each character actually manifested the bodily incarnations and ages of the actors playing them, noted as being 'in her twenties' (Ellen), 'middle thirties' (Bates) and 'forty' (Rumsey) (P3 190). The present tense they employ, though, indicates minds much older than these bodies: Bates complains of his impudent, young neighbours dismissing him as 'Grandad' (P3 193) and Ellen speaks of an elderly drinking partner who quizzes her about her 'early life' (P3 194). It seems Pinter has purposefully crafted a theatrical mind/body split by which aurally we are offered the eddies of aged minds, which chew the cud of missed

opportunities and their consequences, and visually we are presented with the worlds of those memories. This is further emphasized by the movement of characters between the three areas, facilitating three short 'flashback' scenes: the first when Bates moves to Ellen and the second and third when Ellen moves to Rumsey. Nudging us out of our steady modes of listening, the actors' movements ignite our awareness of the bodily reality of these beings, so otherwise engaged in worded memories. These specific memories are easily lodged in our minds, presented as they are in the clear, linear manner in which each had originally unfolded. The effect is precise, for by disturbing the mesmeric poetry which affects an audience emotionally, the presentation of three key scenes from the past places those three memories as tangible contextual matter around which the lyrical work can build. Bates, for example, acts out a time with Ellen when he suggested a walk, going for a drink and, as a last resort, physical love. That each is rejected by her seems to inform this character's present existence, and a relationship to a world he views as claustrophobic, where 'Meadows are walled, and lakes. The sky's a wall' (P3 198), as unkind, providing 'no constant solace' (P3 194), and brutal, 'throw the doors smack into the night' and 'bumping lights' (P3 192).

That Rumsey always stays in his area, whilst Ellen moves twice to join him, and Bates to join her, visually underscores their neediness as opposed to his self-isolating resignation. Speaking of others, he says 'They walk towards me, no, not so, walk in my direction' (P3 198), and the correction he supplies here is symptomatic of his isolationism and an inability to engage empathetically that originally caused him to reject Ellen.

Ellen, the focus of interest for the two men and the backbone to the drama, comes across as ineffective, asexual and unfeeling. Like the other characters, she has distanced herself from others and typically prefers to listen than to talk to her present-day drinking partner. The majority of what Ellen utters is of snatched memory, details of the others to whom she listens, has listened, or on whom she has relied for a self-definition of some kind. Here lies the key to this play; although ostensibly a tale of unrequited love and misguided passion, there is actually very little talk of love. Instead we are presented with three characters engaged in the act of striving to narrate themselves,

using the past as an intermediary and failing to find satisfactory reflections in those who surround them (Ellen's aged friend, Bates's unruly neighbours, Rumsey's horse – which does nevertheless come 'towards him' and not simply 'in his direction'). Their vain acts of self-affirmation provide the main score of this drama, and inform its form as much as its lyrical content. The physical compartmentalizing of actors, the temporal anomalies, the cascading, repeated fragments that accumulate and swirl in the final moments of the play all go toward constructing a torturous tragedy of identity. The silence that constitutes the play's title is incarnated on-stage as a form of existential vacuum:

> Around me sits the night. Such a silence. [. . .] Is it me? Am I silent or speaking? How can I know? Can I know such things? No-one has ever told me. (*P3* 201)

This character's words, eloquently conjuring a sense of isolation and lack of belonging, also seem to be an appeal to the author who is fashioning her, scratching away with pen on paper, alone in his own silent study. By extension, they are an appeal to an audience, who are the ultimate constructors of meaning and who 'author' the play afresh each time by absorbing its information, fusing it with their own being, and thereby supply a 'reading' of their own with its own personal significance.

Both *Landscape* and *Silence*, with their oblique references, hints and clues represent veritable jigsaws that induce in us a temptation for protracted textual analysis. But the significance of, for example, repeated refrains is chiefly a theatrical one. A director and actors will be aware that much of the text of these plays, when spoken, will wash over the audience, who cannot retain the fine details but who will nevertheless be gently affected by their accumulation. It is much the same effect that music has on us; we never question why a shift in key in a piece of music causes a shift in our mood, but simply allow instead its non-rational, almost corporal influence to pleasure us. Such is the effect of Pinter's contrasts (the sun/rain themes in *Landscape*), leitmotifs (the tree-bound shadow in *Silence*), his undercurrents of negativity (each 'flashback' ends in a 'no' in *Silence*) and the pauses and silences that fragment and pace these two plays.

This became Pinter's new dramatic world, one where the conflict need no longer be generated between characters with opposing sets of motives and objectives, but between the isolation of the present moment and the past which is ransacked to supply identity and meaning. In this way, an interrogation of essential human needs is activated powerfully through gentle poetic allusion. The sketch *Night* (1969) might be considered a formalistic exercise in this newly discovered dramatic idiom. Chatting late one evening about the occasion of their first meeting, and of the details of their first embrace, the unnamed Man and Woman recall differing events and nevertheless employ these vague memories to fortify the mutual bond that they both require for self-confirmation. The ten-minute sketch finishes with the couple trading 'I will adore you always' utterances, each significantly deposited, however, as reported speech originating in the mouths of remembered 'women on bridges' and 'men holding your hand' (*P3* 219). It is a poignant ending, in that it is both an expression of shared affection coming at the end of a compromised agreement on events and a cynical undermining of the basis of that affection. The significance and interface of past and present affection in this moving, romantic dialogue between a husband and wife effectively demonstrates a simultaneous intimacy and distance that might be recognized in many of our own relationships.

A quarter of a century later, Pinter returned to the format of *Night* to produce *Ashes to Ashes* (1996) in which Rebecca and Devlin, another husband and wife couple (we assume), are again engaged in discussing the past. As in the earlier sketch, the elusive qualities of past memory, and attempts to appropriate and fix the past bring about frustration and uncertainty. Whereas in *Landscape* and *Silence* the slippage between evocation of the past and experience of the present generates augmented states of isolation, the attempts to bridge the gap in *Night*, and especially in *Ashes to Ashes*, become more invasive and effectively communicative of our primal urge to attain self-definition through 'possession' of another. It is the woman, this time, who does all the remembering whilst the man provokes the flow of information with his prying questions. At first, it seems that jealousy and insecurity inform Devlin's interrogation as he seeks to understand the apparently sado-masochistic

nature of a relationship that Rebecca once had with another man. Gradually, though, we begin to be further disturbed by the details we glean of Rebecca's former lover. Despite being a gentle and cultured gentleman, we learn he was involved in the running of a factory that 'wasn't the usual kind of factory' (P4 404), but was reminiscent in its details of slave labour establishments, and that he acted as a 'guide' for a 'travel agency' who would 'go to the local railway station and walk down the platform and tear all the babies from the arms of their screaming mothers' (P4 406–7). Although Devlin insists and Rebecca agrees that she has no authority to discuss the kinds of atrocities she is claiming to have witnessed, she goes on to describe images of people being led to their deaths in the sea and of outcast refugees stalking icy, star-lit streets.

The cultural and historical vocabulary of our times would indicate that Rebecca's memories are of incidents that took place during the worst years of the Nazi occupation of much of Europe. However, this is categorically nullified by Pinter in his insistent direction that the action of the play takes place 'now' (that is, 1996 at the earliest, when the play was first written and performed) in relation to the characters' ages. Devlin and Rebecca are 'both in their forties' (P4 391) and could not have been born any earlier than the very end of the Second World War. Pinter does not seek to clarify this, and the resultant ambiguity permits an overtly political potential that the play has to suggest that the named atrocities could happen in modern-day Britain, a notion supported by Rebecca's naming Dorset as being the location of her memory of watching refugee figures being led into the sea. Such a suggestion is clearly important to Pinter, and can be supported extra-textually by his repeated warnings, in earlier plays such as *One for the Road*, *Mountain Language* and *Party Time*, of how dangerously immediate fascistic logic can be

In addition to the political dimension, there is a clear domestic agenda at work in this play, and Rebecca's introspective accounts seem to articulate a deep-set guilt that is afflicting her, one which involves a loving but brutal relationship and the giving away or loss of a child. This becomes clear in her explanation of the concept of 'mental elephantiasis' (a description of her current state of being, perhaps) in which she adopts a distancing third-person 'you':

You are not the *victim* of it, you are the *cause* of it. Because it was you [...] who handed over the bundle. (*P4* 417)

Perhaps Rebecca is constructing a personalized, fictional narrative that marries some loss or inadequacy with the barrenness of her present emotional situation. Children (the 'bundle' in question) certainly play a significant thematic role in the play, and the happy details of Rebecca's sister's healthily developing toddlers clashes with the imagery of infants being snatched from mothers at railway stations.

The play cannot be reduced to a tale of a childless marriage, though, and seems more centred on the fluctuations of control, support and individual emotional need in its male/female relationship – standard Pinter concerns. Devlin cannot locate when in the past Rebecca might have enjoyed a relationship with the lover she describes, and his verbally and physically dominating role (he is standing while she is seated) suggests that actually her narrative might in part be a fictionalized analysis of their own relationship. Devlin, in his attempts to appropriate Rebecca's history, is certainly accentuating her trauma, and effectively inculpating himself through his rude invasion. His final imitation of the fist-clenching, throat-gripping posture Rebecca described her lover adopting in the first moments of the play also serves to merge the fictional and the actual. Were the play to end there, having come full circle, it might adequately function as a finely tuned, closed study of aspects of sexual politics. But a theatrical linearity undermines the textual circularity: Firstly we have an escalating introspection on Rebecca's part matched by Devlin's progressive development in tone from voyeuristic insatiability, to irritable pedantry, to brutal insistence. These are complemented visually by a progressively tightening focus effected through a subtle change in lighting states. During the course of the play the light that enters through a large window dims and is replaced by the internal lamplight, which intensifies 'but does not illuminate the room' (*P4* 393). In this way, the audience is drawn gently closer both to the on-stage action and to Rebecca's mental vagaries. Dialogue is replaced by introspection, and the shift from a naturalistic frame that the lighting effects is accentuated by the expressionistic device of having an echo added to Rebecca's words. In this way, Pinter ends the play with a

powerful affirmation of the incident alluded to on the railway platform being a legitimate memory of Rebecca's. She appears to reconcile herself to it and concedes her participation, firstly by adding details that belie her spectator's status:

> She listened to the baby's heartbeat. The baby's heart was still beating.

And finally by switching to a first-person account:

> The baby was breathing.
> *Pause.*
> I held her to me. She was breathing. Her heart was beating.

> (P4 427–8)

The slippage between first and third person is characteristic of much of the previous narrative, and had been first emphasized in Devlin's erroneous reference to a song 'I'm nobody's baby now', corrected by Rebecca to *'You're* nobody's baby now' (P4 402). The incidental focus on this song title, early in the play, serves to forge a link between the words 'baby' and 'darling' (Devlin first hit upon the title as a response to Rebecca's affirmation that 'I'm nobody's darling'), connecting the concepts of love, child-raising and fascistic behaviour. This is the thematic fabric of the play, but the themes are intoned and evoked in refrains, *mises en abime* and metaphoric structures and so cannot achieve absolute expiation. Borrowing this quality from the 'memory plays' of the 1970s, *Ashes to Ashes* is a disturbing and elusive work that efficiently insinuates itself upon an audience's emotional being. The search for truth, as manifested in this play, and the ineluctable unknowability of a life-partner, metaphorically paralleled by the inability to render a precise definition of past events, are typical Pinter motifs, first fully explored in the late sixties, and pursued further in the seventies to fully consider the human traits of attraction, rejection and betrayal.

BETRAYALS AND BRIDGES BURNT

Stating that the 'desire for verification on the part of all of us [...] is understandable', Pinter in a speech made at the 1962 National Student Drama Festival justified his use of characters

who were on the whole incapable of providing trustworthy testimony, either of themselves or of others:

> A character on the stage who can present no convincing argument or information as to his past experience, his present behaviour or his aspirations, nor give a comprehensive analysis of his motives is as legitimate and as worthy of attention as one who, alarmingly, can do all these things. (*VV* 15)

The interaction of characters on the stage, whether it be seeking recognition from others, manifesting superiority or attempting to solicit enriching bonds, nevertheless necessitates the development of strategies to construct such 'convincing arguments' and 'comprehensive analyses'. Clearly, it is these strategies that fascinate Pinter, and not their outcomes in recognized or negotiated 'truth', and his characters often draw an audience's interest in the manner in which they develop procedures to cope with their interaction with others. Lacking any concrete indices for self-verification, they seek to fictionalize themselves in narratives that might oil the wheels of their social interaction. For example, Albert in *A Night Out*, like Deeley (*Old Times*) after him, creates the glamorous alias of a film director to extract respect from the prostitute who picks him up. She in turn assumes the role of mother and housekeeper to apply a veneer of respectability to her profession. Walter in *Night School* ironically upgrades himself from incompetent counterfeiter to gentleman armed robber to impress the girl who has been given lodgings in his room. By permitting us to detect the construction of a character's 'convincing arguments' in this way, Pinter effectively provides a commentary on human emotional interaction and the nature and status of 'truth' within our bonds.

An early development of this fascination is evident in *The Collection*, a TV play from 1961, the dramatic momentum of which is entirely generated by the impulse towards uncovering the truth behind a supposed marital infidelity. Instead of the truth, however, the characters only offer a collection of contradictory narratives to shed light on the alleged affair. James forces himself into Bill and Harry's home to confront the former with an accusation of seducing his wife, Stella, during the showing of a dress collection in Leeds. Bill rejects Stella's account of events that James offers, replacing it with his own story of mild

flirtation and stolen kisses, but only after first adding corroborating details to her account. Annoyed at this interference in his own relationship, Harry confronts Stella, who simply accuses Bill of having concocted the whole story. Bill then qualifies this explanation by admitting that he and Stella did nothing other than indulge in a verbal fantasy of proposed sexual intimacy. The piece closes with James attempting to get Stella to verify this version of events and virtually dictating the final story to her, as if insisting that no other possibilities could now be entertained: 'That's the truth... isn't it?', he maintains (*P2* 145).

What is important for James is not discovering *the* truth, but finding *a* truth that can be accommodated within the parameters of the relationship without disrupting or questioning the existing dynamic between the two partners. His need to believe the relatively innocent version ties him to Harry, who first announces it and arguably conspired with Stella to manufacture and implant it into the negotiations. Both men are the dominant partners and each requires a stability that is seemingly under threat in both relationships. The threat is manifested in the supposed affair between Stella and Bill, but it is not exclusively caused by it as, clearly, both relationships are already in a less than satisfactory condition. The stability is furnished by the final narrative of events in Leeds, as it eliminates the possibility of James or Harry's having been cuckolded. However, Stella's refusal to either confirm or deny this scenario suggests that a conflict between her and her husband has yet to be resolved and it might have been this imbalance that first compelled her to make (or invent) a confession of infidelity. Perhaps, like Sarah in *The Lover*, Stella's original confession was an attempt to ignite with her husband the kind of erotic fantasy she might have engaged in with Bill, a manner of seeking to fuse her sexual identity with her wifely one, thereby signalling a need to be recognized on different levels.

Sally in *Night School* (1960) shares some of these qualities. Being both a primary school teacher by day and a nightclub hostess by night, she easily integrates two seemingly contrasting social roles. Her dual personality causes her no discomfort and she is vocally capable of looking after herself. She represents something of a riddle to Walter, who has returned from jail to live with his two aunts, only to discover they have let

out his room to her. Viewers of this TV drama get early verification of Sally's status as a teacher with a brief shot of her marking books. Walter, however, has only verbal confirmation to go on, and, given that he has learned that Sally's evenings away are at a night school, he is naturally intrigued when he discovers a photograph of her with *'her hair up, sitting at a table with two men. She is wearing a tight, low-cut blouse'*.[3] By enlisting his mentor and fellow petty criminal Solto to track her down among the nightclubs he frequents, Walter seeks to clarify what Sally might represent to him. Is she the wife material that he jokingly insinuates during a late-night brandy-fuelled conversation with her, or is he simply attempting to burst her bubble of respectability in order to get his room back? Alternatively, is his attraction a purely sexual one, as his fetishistic commands to her to sit, stand, cross and uncross her legs might imply? Here, a photograph – a traditional arbiter of truth – instigates a process of verification that seeks to reinforce or undermine perceived fictions – whether Sally is a teacher or nightclub hostess. It is another photograph, left in Walter's room by the departing Sally, that provides confirmation of only one side of the truth: that of Sally as a games teacher.

The irreconcilability of contrasting narratives and the struggle to define and appropriate the truth represent perhaps the irreconcilability of individual emotional needs within any relationship, and the consequent natural impulse that human being have towards betrayal. Betrayal, that is, not just of those who rely upon established emotional bonds, but of ourselves, our own identity, integrity and needs. *The Caretaker*, essentially a doleful tale of trust broken and bridges burnt, is clearly an early example of Pinter exploring this concern.

That the impulses of internal emotional needs can destroy the very structures they seek to adopt is a predicament Pinter sought to trace in a number of his works. As seen, Harry and James in *The Collection* accept compromise to achieve a desired stasis in their relationships. Walter in *Night School* might regain his room, but he undermines a potential alliance by both lying about his own criminal status and checking up on Sally in an underhand manner. In these plays, it is the characters' attempts to attain reassuring verification that leads to the compromise of embracing comforting or merely adequate fictions. The pursuit

of an imposed truth within a relationship, combined with the instinctive application of dissimulation as a *de facto* human activity, made for irresistible intrigues in these early dramas, but was to prove potent dramatic fodder for the more introspective material that the playwright was later to construct. Rejecting an approach that risked stagnating into formula, Pinter in the late sixties felt that he 'couldn't any longer stay in the room with this bunch of people who opened doors and came in and went out,'[4] and he feared, after *The Homecoming*, that he might never be able to write another play. As we have seen, his initial solution to the creative deadlock was to present the mindscapes of his characters, staging the force of conflicting memories in *Landscape* and *Silence*. The liberating creative experience, 'a hell of a release',[5] that these short works represented for him also provided a theatrical solution to the problem of how to avoid the inevitable entrance of yet another intruder figure (by now a Pinter cliché) in his next full-length play, *Old Times* (1970).

In this drama, Kate and her husband Deeley have invited her old room-mate to stay, and the play opens with them discussing her as they await her arrival. Instead of coming on through a door, though, Anna is present on-stage from the onset, even as Deeley and Kate sit and discuss her. The formalistic device of having the character upstage, back to the audience, gazing out of the window and then suddenly taking centre stage with a brisk monologue quickly establishes for the audience how they are to relate to the stage action. It is a clear indication, for one thing, that despite the realistic décor (the lounge of a converted farmhouse) the drama is not necessarily going to develop along naturalistic lines. It also initiates an uncertainty in the audience as to the status of each character. Anna's unconventional introduction might simply come across as a cinematic leap (all three now share after-dinner coffee and brandy) or, lending her an enigmatic reality, it might signal that she is to play something of a phantasmagoriacal role in Deeley and Kate's marriage, that she is the figment of some emotional need or lack between them. Certainly, as Alan Hughes suggests,[6] she appears to have been summoned up by Deeley and Kate, who in their opening dialogue attempt to ascribe characteristics to her (is she fat or thin, a vegetarian, married etc?) as though authoring her presence. This Anna-narrative is further indulged in later when

they discuss her husband and their Sicilian villa, Anna conceding to each surmized detail (bare feet on marble floors, orange juice on the terrace, a view of the sea (*P3* 280)). But if all this serves to make an apparent fiction of Anna, it is a process that Pinter soon turns back on Deeley and Kate in the manner in which their past is excavated. With *Old Times*, it seems, he sought to apply his obsession with how 'the past is not the past' and how one's 'previous parts are alive and present'[7] as theatrical tools with which to analyse the fabric of emotional bonds.

Interrupting a steady dialogue and accelerating the pace of the play with a flowing monologue, Anna's initial vocal presence in Deeley and Kate's living room draws a sharp focus. Kate quickly becomes a secondary role, subsequently having fewer than twenty brief lines in as many minutes. Her marginality is rebalanced in the second act, but at first, by effectively reducing her to the subject of her husband and her old friend's conversation, Pinter demonstrates how a definition of her past becomes a catalyst of her and Deeley's present-day relationship. This, in turn, makes a pivotal role of Deeley and suggests that the crisis that is unravelling in the drama is predominantly his burden. His insecurities might first be kindled by the recollections in Anna's monologue of the independent female lifestyle that she and Kate shared in their youth. She deposits images of flat-sharing and party-going, of sandwiches in Green Park and coffee in élite, bohemian cafés surrounded by stimulating creative artists. Whether her presence on-stage is a real or fantastical one, Anna surely represents for Deeley an incarnation of his wife's past and, with it, facets of her personality that elude his proprietorial emotional demands. His first response is a defensive one, fending off suggestions that he and Kate now live a dull, secluded life by stating that his work often takes him away. Then, detecting a precociousness in Anna's command of vocabulary, he makes a point of drawing attention to it (her use of words such as 'lest', 'gaze' and 'beguilingly'), dismissing it as possessing 'emotional political sociological and psychological pretensions and resonances' (*P3* 278). From this early defensiveness stems a need in him to clearly stake a claim to Kate, challenging Anna as a perceived rival.

They first lock horns subtly in an exchange of song lyrics, inspired by the title of 'Lovely to Look at, Delightful to Know'

which, applied to Kate, accentuates the notion of rivalry. Anna sings of infatuation ('The way you comb your hair', 'you're lovely, with your smile so warm', 'you are the promised kiss of springtime') whilst Deeley sings of ownership ('I've got a woman', 'all the things you are, are mine') only to join together in that paean to the ecstasies of remembrance and lost love, 'These Foolish Things'. When they sing such lyrics again in the second act they do so 'faster on cue, and more perfunctorily' (*P3* 296), making something of a challenge of getting to and uttering the defiant and triumphant title lyrics of Gershwin's 'They Can't Take That Away from Me'.

Following the initial burst of song, Deeley decides to show his hand and delves into the past to speak of how he and Kate first met at a cinema during a viewing of the ironically titled *Odd Man Out* starring Robert Newton. Anna's response is to warn him that the past holds no concrete significance:

> There are some things one remembers even though they may never have happened. There are things I remember which may never have happened but as I recall them so they take place. (*P3* 269–70)

Central to the theme of the play, this speech effectively robs Deeley of his arsenal and this is noted in his exasperated, monosyllabic response, '*What?*', italicized in the script to emphasize the impact. Anna's words also alert all three characters to the notion that they are each susceptible to a fictionalization of personality through a reappropriation of the past. Pinter powerfully demonstrates how the past is a terrain to be plundered and exploited for confirmation of identity and the territorial stratagems of the characters in his early writings are now executed on the vague shifts and turns of recollection.

Anna applies the logic of her statement by re-authoring the events that Deeley has so far recollected, remembering a time when Kate and she went to the cinema together to see *Odd Man Out*. She also writes Deeley into their life of twenty years ago, presenting him as a man sobbing in the night, making failed advances to both of them and then leaving, only to reappear in a submissive attitude on Kate's lap. At first Deeley rejects the portrait but will later concoct or recall details of his own that will confirm its possibility. In the second act he goes on the offensive and begins to paint a less than flattering image of Anna in the

past. He recalls meeting her in a pub and her permissively disregarding his looking up her skirt. With the tables turned, Anna first denies all knowledge, but each attempt she makes to invalidate the possibility ('I didn't have money for alcohol') is overturned by a swift rejoinder from Deeley ('You didn't have to pay. You were looked after.'(*P3* 287 and 288)). When Kate joins them after her bath, Anna happily elaborates upon this latest recollection by revealing that it had been Kate's underwear that she had been wearing, borrowed without permission, and that on her return home she had made her confession and aroused Kate with stories of men staring up her skirt.

The delight that Anna speaks of in relating the details of her conquests in Kate's underwear, and the coy titillation that Kate enjoyed serves to bind the two women. The memory of this reciprocal sexual arrangement also adds to the underlying lesbianism that is apparent in the play, and the implied sexual exclusivity alienates Deeley further. This is theatrically embodied in two brief sequences in which Kate and Anna discuss clothes, boyfriends and what to do together that evening. Possessing all the qualities of flashbacks, these scenes are dismissive of Deeley's presence and the on-stage tripartite of shifting eye contact brings this efficiently home to an audience. All innuendo about a prior sexual relationship makes an active rival of Anna, and Deeley is perhaps attempting to prize out confirmation of this in his talk of how Anna might be best suited to drying Kate off once she comes out of her bath. His claim to have 'had a scene' (*P3* 307) with Anna twenty years previously, before knowing Kate, is perhaps a way of negating this female sexuality, but Anna succeeds in reinforcing the notion by claiming that Kate was created in her image: 'I found her' (*P3* 307).

It is at this point that Deeley's situation reaches its nadir, because now his wife's past has been 'written' in such a way as to reflect painfully upon their present condition. The second act is played in the bedroom, the more private heartland of this marriage, and Deeley himself draws attention to the fact that Kate and he sleep in different beds. Earlier in the play Anna managed to allude to this conjugal sterility with a slip of the tongue which equated marriage with a dreary everydayness: 'You have a lovely casserole [...] I mean wife' (*P3* 258). By merging her own past promiscuity and present lifestyle with

Kate's 'parson's daughter' (*P3* 302) disposition, Anna manages to ridicule Deeley's fantasies of a more adventurous or sexually assertive wife. Deeley's best chance of overriding this is to accept this integration of Anna's and his wife's sexuality by once again changing his recollection of his 'scene' with Anna: 'Maybe she was you', he says to Kate (*P3* 307).

Finally, the play takes an unexpected turn that produces a last burst of momentum, suggesting an impending dénouement to its audience. Kate suddenly asserts herself and engages in the narratives that have so far been woven exclusively by her husband and old friend. She first accepts the merging of her and Anna's identities by accepting her husband's 'confession' of having had a scene with Anna twenty years ago, but replacing the permissive sexuality with gentle affection: 'She found your face very sensitive, vulnerable [...] She wanted to comfort it, in the way only a woman can [...] She fell in love with you' (*P3* 308). Once she has done this she can 'kill' Anna off, erasing her from the recital. Her description of Anna's 'death' – a ritual bed-top burial with her inert, dirty face on immaculate sheets – effectively cuts off all issue Anna has to claims over her identity or sexuality, a rejection already implicit in her earlier rejection of London's hard water, 'harsh lines' and 'urgency' (*P3* 297). Then, placing Deeley in the picture, she clearly paints him in as a successor to Anna in her affections ('When I brought him into the room your body of course had gone' (*P3* 310)), only to efface him from the past too by describing how she attempted to coerce him into the same (remembered or invented) death ritual. The battleground of past identities has been washed clean, and Kate survives by ultimately rejecting the objectification she has had to endure at the hands of the two rivals. The play then closes with an enactment of Anna's recollection of the man sobbing in a room. Deeley bursts into tears, stops, and approaches both women in turn on their divans. Rejected by both, he makes to leave, only to return and lie submissively on Kate's lap. He then gets up and slumps in an armchair. There is a silence and then the lights are raised sharply, impressing the final, fixed image of three isolated souls into the audience's minds.

Any attempt to answer the enigma of *Old Times* is incon-clusive. Perhaps, as Hughes proposes, Anna is a fictive creation of Kate and Deeley's marriage, akin to Max in *The Lover*. Maybe

the play is the subconscious representation of Deeley's deepest sexual and emotional fears or the portrayal of actual one-upmanship between three real people, both possibilities that Martin Esslin entertains.[8] It does not matter which of many such interpretations we decide to support as all they provide are frameworks of understanding that appease the rational mind's disquiet. But it is not to the rational mind that the play in performance predominantly appeals. Whichever understanding of Pinter's text we settle for, the theatrical effects of his accumulations are the same – both the irreconcilability of individual passions and the fiction-like qualities of remembrance resound effectively.

Our confusion when faced with a performance of *Old Times* is purposefully engineered. We are made to experience two disorienting facts of human existence, which, sharing the same 'shape', reinforce one another when activated in the theatrical contract. One is that we cannot construct indisputable definitions of past events and emotional interaction. The other is that, ultimately, we cannot know one another. Perhaps what Pinter is stating in evoking and binding these two experiential truisms is that human responses to them frequently entail varying degrees of inauthentic behaviour, that is to say behaviour that involves misrepresentation of oneself and calculated abuse of others for personal advantage. This might certainly be considered one of the moral warnings of *The Dwarfs*, where such inauthentic behaviour festers and destroys genuine human contact. The human dilemma that Pinter seems set on exploring is how our need for consistency involves developing a trust in what others project of themselves. The dilemma is articulated most precisely by the character of Len in *The Dwarfs*:

> Occasionally I believe I perceive a little of what you are but that's pure accident. Pure accident on both our parts, the perceived and the perceiver. It's nothing like an accident, it's deliberate, it's joint pretence. We depend on these accidents, on these contrived accidents, to continue. (*P2* 100)

Len's awareness that identity is 'the sum of so many reflections' and that perception of others is a complex struggle to distinguish between the 'scum and the essence' (*P2* 100) is in part symptomatic of his own ontological crisis, but also serves as

an illustrative pattern for what is happening in his two friends' decaying relationship. In the original novel, Pete describes a *modus operandi* that avoids Len's distinction:

> The art of dealing with others is one, to be able to see through them, and two, to keep your trap shut. If you've got kop enough for the first and control enough for the second you're a made man. (*TD* 99)

Curiously, Pete earlier accuses Mark of 'operating on life and not in it' (*TD* 79), berating him for just the kind of disengagement he later advocates. Of course, Teddy in *The Homecoming* claims to 'operate on things not in things' (*P3* 69). Indeed, it is declared as a sort of emotional credo. He sees himself as free from the network of instinctive, animalistic reactions he perceives in his family. Consequently, he will not be disturbed by his wife's acceptance of their offer to set herself up as their homemaker and whore, for he considers himself superior, capable of observing their behaviour and thereby emotionally distancing himself from it. The only real example he can give of this ability to operate 'on' things, however, is his stealing of Lenny's cheese roll, which he describes as a process of observed stimuli: 'I saw you put it there. I was hungry, so I ate it' (*P3* 72). He demonstrably makes no apology for this, as this would imply his operating 'in' the situation, and recognizing codes of behaviour. Effectively, though, his gesture is reducible to his swapping a wife for a cheese roll, and a simple, pathetic, powerless act of vengeance on his brother. His brother Lenny is clearly far more capable of operating on things. His wife Ruth proves more capable still.

Understanding the difference between characters that operate 'on' and 'in' things by, as Len of *The Dwarfs* points out, varying degrees of (conscious or subconscious) pretence, and the control and empowerment that these provide, is clearly a significant key to appreciating Pinter's dramatic goals. It might certainly be of practical use to actors and directors to consider each character in this respect. *The Dwarfs*, itself, goes some way towards examining the effects of different conscious levels of manipulation within friendship. Friends since adolescence, the different strategies of detachment from the demands of the adult world that Len, Mark and Pete adopt are eventually articulated in the manner in which they relate to one another. It is the consequences of these

strategies that both the novel and the play chart. Specifically, it is Mark and Pete who are on the brink of breaking apart, whilst Len, their mutual friend, is undergoing a mental breakdown that both parallels and illustrates the disintegration. He is disturbed in the extreme, and manifests schizophrenic characteristics in his visions of teams of dwarfs which allow him to both displace and face his own mental decay. This decay is articulated in terms of food, its putrefaction, digestion or bodily expulsion.

The play takes the form, mostly, of a series of dialogues between various pairings of the three men, interspersed with Len's delusional monologues. Both Pete and Mark warn Len away from his friendship with the other, betraying their own growing animosity for one another and their apparent indifference to Len's own suffering. The decay of friendship is also paralleled by some of the imagery that Pinter employs within Len's experience. The references to stale or decaying food, sour milk and corked wine accumulate to represent the lack of nourishment these three gain from one another. That Pinter changes the cause of Len's hospitalization from bowel trouble (in the novel and radio adaptation) to kidney trouble (in the stage adaptation) is perhaps significant in that the kidneys are not simply organs that process bodily excreta, but serve to filter and purge. Len's hospital bed might be the bed of his re-birth, for his physical treatment coincides with his mental reparation and it is here that the play's strands intertwine. Having visited Len in this hospital bed, Mark and Pete engage in a brief purgative confrontation. Their argument ends in a bitter exchange that suggests both the festering nature of their resentment, and the emptiness that their separation will effect:

MARK. You know what you are? You're an infection.
PETE. Don't believe it. All I've got to do to destroy you is leave you as you wish to be.

(P2 104)

The two-minute altercation replaces an extremely lengthy conversation given in the novel. The physical void left on-stage as Pete exits, and the silence following their row, are far more dramatically articulate of their loss. Len's final soliloquy, following the purging effects of physical illness (vomiting and

diarrhoea), suggests not only that his mental illness is combated, the dwarfs now having departed, but also the solitude of new beginnings when friendships are broken and 'all is bare. All is clean. All is scrubbed' (*P2* 105).

In the novel of *The Dwarfs*, it was the sharing sexually of Virginia that served as the catalyst to the breakdown of Pete and Mark's friendship, a sexual betrayal revealing a network of other interpersonal betrayals. Conversely, it is the sharing of a sexual partner that seems perversely to reinforce the bond between men in *Betrayal* (1978), a notion that had already been briefly explored in the TV drama *Monologue* (1973). Here the void left by dissolved friendship is illustrated plainly by the empty seat to which Man speaks, reminiscing on his friend and the black girl with whom they were both enamoured. His old friend loved the girl's soul like Pete of *The Dwarfs* loved Virginia's. The speaker, like Mark, had held a carnal desire for her. As if to emphasize the inevitable incompatibility, he remembers his friend possessing the more masculine body and the girl loving his (the speaker's) soul. But this contrast also serves to bond the two men, as if their possession of mutually complementary characteristics (also seen in his friend's emotional detachment as against the speaker's romanticism) makes one man of the two. In this, the existence of the girl seems almost incidental ('My spasms could have been your spasms' (*P4* 124)) except that she temporarily served as the fulcrum to their meaningful bond. In painful irony, their shared desire was probably also the cause of their separation, and the loneliness it is implied they both now endure. In *Monologue*, then, we have the germ of *Betrayal* which, like an inversion of *Old Times*, unravels the emotional trauma between two men and a woman they have both loved.

At first, *Betrayal* comes across as atypical Pinter in that theatrically it seems to revert to the kinds of pre-war dramatic styles and concerns that his early work parodied and effectively supplanted. Its subject matter is the blandest of dramatic material: an extra-marital love affair involving three emotionally retentive, middle-class socialites: a publisher (Robert), a literary agent (Jerry) and an art gallery manager (Emma). Formalistically, the play has none of the expected traits. For once there is no ambiguity at play, no mysterious behaviour, no shifty intruders, no subtle power games or threats of violence. Instead, here is a

work which actually permits the audience access to knowledge that its characters lack, which provides a more or less clear understanding of their motives and a succinct delineation of their personalities. Perhaps it was for reasons such as these that the initial critical reaction to the play was, on the whole, only lukewarm. Pinter was perceived by some as treading water, pandering to the kinds of audience that he had direct access to in 1978 as a director of the National Theatre. He was criticized for merely staging the petty concerns of the 'stagnant pond of bourgeois-affluent life',[9] a world of business lunches, trips to New York and holidays in Venice.

And yet there is much in *Betrayal* that is classic Pinter. By charting the affair between Jerry and Emma backwards from the emotional wreckage of its aftermath to the glorious intoxication of its inception, he was able to mine the seemingly trivial love triangle for fresh commentary on the nature of inter- and intra-sexual emotional involvement and the deceptive quality of assumed causality, themes that have informed a good deal of his writing. This backwards plot development is the play's most conspicuous formalistic device and is the feature that generates all of its dramatic tension. The montage owes a great deal of its overtly cinematic structure to Pinter's experience as a screen-writer and is characteristic of his ability to render the subjective perspective of the narrating voice in a novel into an objective presentation of events. Applying this skill dramatically, he managed to circumnavigate another potential impasse in his writing and, instead of characters again structuring their subjective recollections of the past to justify or define their present being, we are presented with a detached, almost documentary collection of scenes from that past, allowing us to contemplate the causal chain.

The beginning of the play has an incredible emotional dynamism. Although Emma and Jerry are ill at ease after being separated for so long, there is enough emotional residue between them to suggest the possibility of reconciliation or the emotional closure they both evidently need. Emma's confession of driving past the flat where they once shared their illicit afternoons and Jerry's repeated 'I don't need to *think* of you' (P4 9) are charged with potential pathos. Once intoned, these things are left unexploited, and it is the crushing

revelation for Jerry that Robert has finally discovered his affair with Emma that gives the play its initial inertia. Indeed, this instigates scene two, between Robert and Jerry, in which Jerry is further devastated to learn that his friend has in fact known of the affair for four years, not simply one day. His emotional reaction to this, as opposed to his relatively calm response to Emma, suggests that it is his friendship with Robert that holds the most importance for him. Robert's long-standing simulation of ignorance seems the greater betrayal, one that is compounded by Jerry's being replaced as Robert's squash partner by Casey, the off-stage character who is displacing him in all fields as the cycle of betrayal is being repeated. This initial emphasis, captured by a burst forward in time between scenes one and two, suggests that the play is chiefly concerned with (male) friendship, not the morality of infidelity.

In fact the play quite categorically refuses to comment on betrayal and, if anything, it presents infidelity as pretty much the sexual status quo, a norm to which all of its characters conform. In Jerry and Emma's awkward conversation in a pub in the very first scene, we learn not only that they are meeting two years after the end of their affair, but that Emma has entered a relationship with Jerry's protégé Casey (whom we later learn has also had marital difficulties) and that her husband Robert has perpetrated serial infidelity throughout their marriage. Later, the loaded comment that Emma was not wearing white at her wedding is dropped into conversation. Even Jerry's unseen wife Judith has an admirer and enjoys secret lunches at Fortnum and Mason's. By equalizing the characters in this way, Pinter deposits betrayal as a symptom and not a disease in itself, and uses its presentation as a catalyst of human interaction. Certainly the play seems to provide a study of different kinds of betrayal: the betrayal between husband and wife or between friends, the betrayal between adulterers, the betrayal of artistic ideals and of personal integrity. These numerous betrayals seem only to provide a structure, though, not a thematic focus.

As already illustrated, the destructive intrusion of a female into a solid male friendship, and the comparative inadequacy of the ensuing sexual relationship, is a situation that is illustrated in numerous other works. This is in part dissatisfying in that it invites misogynistic readings of the play. Robert's liturgy to the

exclusively male experience of squash-playing and its associated rituals (shower, pub, lunch) does little to undermine this. However, Pinter's characterization of Emma is a great improvement on the two-dimensionality of many of the female characters that populate his early work. Though as apparently emotionally arid as Jerry and Robert, she comes across as more purposeful, as better at adjusting than the two men, and her unequivocal 'it's all all over' (*P4* 23) indicates as much. Running an art gallery, she has clearly progressed from the home-maker we later meet, as domestic a being as the stew, apron, tablecloth and curtains that define her. Katherine Burkman charts Emma's self-definition by noting her progression towards liberating creativity in her three relationships; taking her from publisher, to agent, to writer.[10] This comparative dynamism even manifests itself in an earlier desire to escape from her duplicitous situation and make an honest man of Jerry. The hesitation in her 'Tell me ... have you ever thought ... of changing your life?' (*P4* 108) three years into the affair (scene eight) draws attention to the 'leaving your wife' concealed behind its rhyming euphemism. Emma is also more likeable than the two male characters. Robert loses our votes quite early with his confession in scene two of giving his wife the occasional, gratuitous 'good bashing' (*P4* 33). Jerry, although the tragic focus of the drama, comes across as ineffectual and cowardly, and behaviour such as his facetious irritation with the waiter in scene seven conveys an unattractive pettiness. It is one of the qualities of the backward movement of the play, though, that it permits us to empathize with the emotional torment of such unsympathetic characters.

Jerry and Robert's bond stems back to their days as poetry editors at Oxford and Cambridge universities and it has been a shared love of literature that has informed their continued relationship as friends and colleagues. The betrayal of these instincts, as incarnated in Casey (who has compromised his early ideals and now writes commercially profitable literature), seems at the heart of their emotional sterility. Their only attempt at addressing their state is in a pseudo-philosophical discussion they share over why 'boy babies cry more than girl babies' (*P4* 49), but, rather than this leading to any significant analysis of their masculinity, they settle for the fatuous commonplace that it has 'something to do with the difference between the sexes' (*P4* 52).

In any attempt to pursue this enquiry the play only really begins to unravel Jerry's masculinity. His emotional quest is defined by his friendship with Robert and motivated by a latent admiration that compels him to imitate his friend's characteristics: agreeing to play squash which is clearly not to his tastes, acquiring a taste for W. B. Yeats over Ford Madox Ford, and, ultimately, possessing Emma. Reinforcing the bond, Robert states in a put-down to Emma that the affection is mutual:

> I've always liked Jerry. To be honest, I've always liked him rather more than I've liked you. Maybe I should have had an affair with him myself. (P4 72)

It is in the nature of adultery that two people share one sexual partner. In this case both Robert and Jerry are conscious of this common ground. The purpose of scene seven between the two men, following Robert's discovery of his wife and friend's betrayals, is to demonstrate how he comes to terms with the revelation and, as he shifts from barely disguised outrage to apologetic warmth, we see how he decides to place his friendship above his marriage. Its closing line, 'She'd love to see you' (P4 100), is his final acceptance of sharing his wife and is as morally disappointing (though curiously more dignifying) than Jerry's 'impossible' (P4 108) response to the notion of changing his life/wife. A sexual bond between men through the intermediary of a shared woman was central to *Monologue* (1973), but here it is emphasized as being the most tenuous of links, and characteristic of an emotional immaturity. The complacent stalemate it imposes is ultimately unsatisfactory for Emma. Her active striving to release her life from stasis and seek fulfilment in her art gallery seems to have been the cause of the breakdown of her affair with Jerry, not his complaint that they can no longer find afternoons to spend together (the gallery, after all, is closed on Thursday afternoons we are told). Jerry's scene three excuse is made out to be little more than resentment at her successful personal development and a desire to maintain instead their comfortable, semi-domestic arrangement, with her as the provider of casseroles and packed lunches.

This domesticity is a form of stability which all the characters desire but which demands compromises that none of them wholly embrace. The repeated references to home and to

children emphasize the form of family unit which each character aspires to create and maintain. The refrain-like reference to an incident when Jerry threw Emma and Robert's daughter in the air one Christmas seems to atrophy this longing for a familial bond between all three characters, a drawing together of their two families, but also effectively and ironically serves as representative of their closeness and the deception that separates them. The different financial and welfare concerns between stage and film for child actors permitted their actual inclusion into Pinter's screenplay for the 1982 film version of the play,[11] reinforcing their significance in Emma, Jerry and Robert's emotional landscape.

Betrayal is characterized by a very British, tight-lipped, emotional restraint. Nevertheless, there are deep seams of trauma deposited in the subtext that are ready to break through to the surface. Emma's frustration at being unable to detach her key to the flat from her keyring is such a moment. The most palpable example, though, is the scene in a Venice hotel room between her and Robert in which he reveals that, having been offered Jerry's letter to her in the American Express office, he has uncovered their deception. His response to her straightforward confession is ridiculously matter-of-fact:

EMMA. We're lovers.
ROBERT. Ah. Yes. I thought it might be something like that, something along those lines.

(P4 69)

Yet, shortly after, his despair is vocalized in his incredulous repetition of her apology and of her admission that the affair is five years in. His italicized '*Sorry?*' and '*Five years?*' (P4 70 and 71) are respectively followed by a silence and a pause. Theatrically, these are excruciatingly painful moments, one accumulating upon the other. The silences trap us in that pain, awaiting release in some emotional rapprochement between these two on-stage characters. We are denied the release, and when Robert states that he 'could very easily be a total stranger' (P4 65) his assessment is painfully apt. The isolation is only further reinforced by his solo journey to the island Torchello to read Yeats. So far we have viewed Robert as a morally vague character. Now, seeing his torment, we experience a slight

culpability at that assessment. We are both drawn in to the drama and isolated from it, and become strongly aware of the distance that separates each of these characters. It is a distance that is emphasized by the on-stage image that confronts us of Emma on the hotel bed and Robert 'at window looking out' (P4 60) that is, with his back to her, attitudes that Pinter establishes at the beginning of scene five and never adjusts in the script. With Emma's nose in a book that links her to Jerry (he has embraced the author that Robert rejected) and her husband's eyes seeking solace in distant objects, the positioning of their dialogue could not be more desperate.

The play's final scene, set at the earliest point in time, manages to dispel some of the strain of the previous scenes with the part-comic, part-pathetic figure of a drunken, youthful Jerry hiding in the marital bedroom from a party at Robert and Emma's house, waiting to declare his affection for Emma who he knows will come to brush her hair. Had the play taken the usual course and begun with this scene, it might have filled us with joy and expectation. Instead, it is an unhappy conclusion for we already know the sterile results of all this promise. Pinter's parting shot is of Robert disturbing the two potential lovers, accepting his friend's explanation that 'I decided to take this opportunity to tell your wife how beautiful she was' (P4 116) and, clasping Jerry's shoulder, leaving the two together to seal their fate. With this, there is a minor suggestion that it is not Robert's misplaced trust but his complacency that might have instigated the affair between his wife and best friend; a further betrayal of husband and wife. As Emma and Jerry stare into each other's eyes, we become aware of the cumulative effect of the reversed time sequence, producing a desperately sad conclusion to the drama.

One might consider this time-reversal technique an example of the infamous *Verfremdungseffekt* of Bertolt Brecht's theatre, whereby dramatic surprise and tension are undermined by early revelation of key factors. The link between cause and effect is thus highlighted, permitting an audience to retain a degree of objectivity through their emphatic consciousness of cause as opposed to an indulgence in the emotional resonances of effect. In *Betrayal*, where we might have grown to sympathize with characters or despise them had the drama proceeded in a logical

order, we are forced instead to consider the characters' behaviour in terms of its future consequences not just for others, but for themselves. Our empathy causes any response of indignation or sorrow to be directed equally at all the three characters, and consequently back into ourselves. In this way, the play effectively presents how the discourses of human social and sexual interaction are constructed of necessary deceits and how honesty and integrity are too easily disposed of, the first victims of a very human need to belong, to succeed emotionally, to avoid isolation. The consequence upon these characters is that they are dehumanized somewhat and lack real emotional expression, caught as they are with an irreconcilable tension between a stability that is underpinned by duplicity and a progression that requires integrity and individualism.

BETWEEN LIFE AND DEATH

Illustrated by *Betrayal*, the contradictory impulses of maintaining comfortable stability and seeking life-affirming progression have immensely attractive dramatic value and this is a dialectic that can be detected in many of Pinter's plays. Additionally, the poetic and metaphoric structures afforded by the life/death dichotomy are naturally attuned to this first binary contingency, and Pinter is seen to apply this in a collection of his later plays as if to reinforce notions of irreconcilable desires or conflicts. Plays such as *No Man's Land* (1975), *Family Voices* (1980), *Victoria Station* and *A Kind of Alaska* (both 1982) and *Moonlight* (1991) all seem to profit from the potent theatrical structuring these combined contradictions accommodate, and the intense emotional experience these plays provide stems from this aesthetic principle.

Furthermore, Pinter often adopts familial structures, the foundation of all human interpersonal behaviour, to illustrate the contradictory attractions of stasis and progression (and, by extension, metaphoric life and death). The impulse of family is towards contraction, closing in on itself protectively, but the individual must reconcile this retrogressive impulse with the compulsion to seek new contacts, to face the challenges of the world and establish new social or biological families. Whereas in earlier plays such as *The Birthday Party*, *A Night Out*

and *The Homecoming*, Pinter evoked the family unit as a metaphor for repression or manipulation, in many later plays he utilized the bonds as representative of the human need to belong, to have a definable emotional location.

The radio play *Family Voices*,[12] for example, articulates an imbalance between the impulse to remain and the impulse to effect change, and the difficulty of finding harmony between them. The play takes the form of a non-connecting dialogue between a young man, Voice 1, and his mother, Voice 2. The son's words represent a synapse between two families, as he speaks of the group of people who share the house in which he now lodges. His mother reproaches him for having lost touch with her. As the play is drawing to a close, the voice of the man's dead father joins in to greet his son. Voice 1 addresses his mother throughout and voices 2 and 3 direct their words at their son, and yet none hear or respond to the others. Each is a voice set in isolation, and in each there is a craving for contact and recognition. It is the tragic distance between a mother and her son that sets the tone for this drama which, despite its humorous content, articulates precisely the desire for belonging and the fear of paralysing isolation. The voice of the father perhaps serves as a potent reminder that death is the greatest barrier between people who love one another, emphasizing the tragedy of failed communication. That this 'dead' consciousness can join in and meet the others on equal terms enhances the suggestion that any hope of actual communication is hollow.

Voice 1 relates to his mother details of the Withers family with whom he now resides, and recounts the incidents and conversations that have taken place between him and each of them in their various rooms. Many of these tales smack of the exposure of a sexual *ingénu* to a promiscuous world of temptation and predatory advances. Lady Withers, who wears red dresses and who receives late-night visits, and her pre-pubescent daughter who juggles currant buns in her stocking feet on the protagonist's lap certainly suggest this. Voice 1, though, seems unthreatened by this environment and declares himself happily settled: 'Oh mother, I have found my home, my family' (*P4* 141). Nevertheless, he repeatedly speaks of returning to see his mother and father. This contentedness and forward-looking attitude is contrasted by his mother's existence, 'alone

by an indifferent fire, curtains closed, night, winter' (P4 140), and her harking back to her son's youth. Within these two static states, then, we are offered impulses forwards and backwards, representative of specific desires and needs. These are never satiated, and in the play's closing moments both Voice 1 and Voice 2 seem to express a resignation to this. Closing the play, Voice 3 sets the seal to the emotional to-and-froing of the mother's appeal and denial and the son's elation and confusion. His plaintive final words are something more than a dramatic punctuation mark. In the closure of their rhyming couplet is a sad warning to avoid isolation, to find the spaces of our emotional belonging, before it is too late:

> I have so much to say to you. But I am quite dead. What I have to say to you will never be said. (P4 148)

Perhaps Pinter's most powerful articulation of the friction between stasis and progression was his 1975 play, *No Man's Land*. Here too, impulses forward and backward operate against static states and, indeed, inform the play's dramatic structure. This is clear from the first scene, in which we discover two well-spoken, ageing gentlemen (the alcoholic Hirst and his guest, Spooner) enjoying a few drinks together, indulging in wordiness and drunkenness, and discussing the salvation of (and in) the English language. The contrast between the intoxications of drink and words immediately sets in operation an almost body/ mind dialectic between oblivion and erudition and, as if to underscore this, the only distinctive features of the stage décor of a large, sparsely furnished room are its book-lined wall and its central, amply-stocked, antique drinks cabinet. 'Through art to virtue' (P3 334), the two men toast, and we glean in both of them a hopeful attachment to poetry as salvation from the fixedness of their present conditions, atrophied further in wallowing drunkenness. Yet, although they both claim to be poets, neither is presently capable of such creativity and both are only involved in artistry at one remove: Hirst is now writing critical essays and Spooner hosts poetry readings in a room above a pub. Here art, the pursuit of poetic expression, serves perhaps as a metaphor for dignifying human activity, and, as poets, the meeting between these two men might prove mutually beneficial.

The play is a collection of manoeuvres between Spooner and Hirst that might clarify the nature of that mutual benefit. Like Davies in *The Caretaker*, Spooner quickly realizes that it would be to his advantage to gain a foothold in his host's household and attempts to ingratiate himself. He meets his Mick-like nemesis in Hirst's two manservants Foster and Briggs, who together manifest some of the menacing qualities of the previous hard-man couple Goldberg and McCann. Games of territorial negotiation are matched with attempts to gain advantage through invocations of the past, but the drama ends in a stalemate implied by its title. In his final pleas, Spooner vainly attempts to insist upon the advantage he represents to Hirst by helping reignite his creative flame. Evidently, though, this might also bring about the eventual displacement of Hirst by Spooner, a cycle of progression that is fiercely guarded against by Foster who, as a budding poet, might have set his sights on displacing Hirst himself.

Spooner and Hirst's relationship is an ambiguous one: they first come across as strangers, but later they behave like old chums. Often, perhaps, they are simply constructing linguistic puzzles, the rules of which they adapt or conform to as best serves their advantage. In this way, Hirst's sober recognition of Spooner as his old friend Charles Wetherby, in Act Two, and confession of having conducted an affair with his wife might simply be a fiction constructed to counter Spooner's Act One taunts about Hirst's ex-wife and implied impotency. This verbal parrying might equally well be the confrontation of wily strangers or the rituals of old friends, but the game-playing effectively forms a long negotiation process by which each attempts to define for themselves the advantage the other might represent.

Clearly, Hirst and Spooner are each afflicted by an isolationism that they both nevertheless perpetuate. Spooner claims to be reassured by the indifference he inspires in others and that he gains strength from never having been loved, but this wilful seclusion is transparently little more than a protective guise. He clearly desires to escape his 'fixed, concrete' (*P3* 323) identity and find solace in the kind of lifestyle being engaged as Hirst's secretary would offer. Hirst, in turn, is trapped in a painfully sterile existence and Spooner might offer more than simply the

temporary release of conversation. One quickly senses some deep-set misery fixed in his early drunken reticence. His tolerance of Spooner's 'gabbling' and uneasy drawing aside of the curtains reflect both his resignation and his restlessness, but also indicate the ultimately dissatisfying quality of the sad predilection he has for picking up strangers in a desperate need for company. By offering Spooner one of the two large mugs that signify his need for companionship, Hirst seemingly completes the bond, and the two men continue to identify themselves as kindred spirits. Spooner applies gentle flattery and implies a shared love of poetry and a common background of some lost, carefree existence: 'What happened to our cottages? What happened to our lawns?' (P3 335). Believing himself to have the upper hand, he sows the seeds of his downfall by switching from flattery to cruel taunts and, imitating the jeering mockery of a Feste or a Touchstone, effortlessly pries from Hirst a tired confession:

> Tonight...my friend...you find me on the last lap of a race...I had long forgotten to run. (P3 338)

Seeing his opponent weakening, Spooner digs in further only to induce a cataleptic fit in Hirst, who crawls from the room on all fours following the awkward utterance of the play's key motif:

> No man's land...does not move...or change...or grow old... remains...forever...icy...silent. (P3 340)

In applying the tactic of ridicule in order to prize open a manipulable vulnerability and insinuate himself into Hirst's comfortable home, Spooner has made the error of believing Hirst's declaration that he shares the house with no one. The appearance of Foster and Briggs requires a tactical shift, but when Hirst returns he now has Spooner outnumbered and, by denying all knowledge of him, leaves him isolated and threatened. He overturns Spooner's previous references to the past by stating that his past is fixed, immutable, in his photograph album. Descending to a morose dwelling on this past and complaining of being stifled ('They're blotting me out' (P3 352)), Hirst gives Spooner his opportunity to ingratiate himself by identifying with the old man and siding with him

against his servants, who clearly have a grip on power in the household. 'There's a gap in me,' Hirst complains, 'I can't fill it' (*P3* 352). When he speaks of someone drowning in his dreams, he seems to be invoking some spiritual and emotional paralysis. Spooner offers to bridge the gap and, claiming to be the drowning man of his dreams, physically props up Hirst, symbolically replacing Briggs who, rejected, had offered the same service. Similarly, in Act Two, Spooner fetches a bottle for Hirst after Briggs has refused to do so, and such simple visual touches articulate as much to the observer as any linguistic struggle. This new dynamic, and the visual opposition it offers between the two old men and Foster and Briggs, concludes the first act. Hirst is led back to bed and Spooner is locked in, Foster switching the light off in a final, dismissive gesture of contempt.

Up to the end of the first act the drama has managed to set in operation the crucial elements of the human dilemmas it seeks to explore: a desire for verification and self-definition, the consequent stifling dependence on others and the atrophy and disempowerment of ageing. By this point, then, the play has expressed all it needs to say thematically, and all that is required of Act Two is that it develops certain motifs and offers its audience a resolution of the 'crisis' of what to do with Spooner. But at the interval our sympathies are confused. Spooner has already demonstrated that he is not to be trusted, but he does seem potentially capable of providing Hirst with a new lease of life, and his treatment at the hands of Foster and Briggs seems unwarranted and excessive. His assessment of Briggs as the 'shark in the harbour' (*P3* 364) indicates his and our realization that this shelter is far from safe. Briggs's anecdote of meeting Foster on a street corner and directing him into a notoriously impenetrable one-way system around Balsover Street is, to all intents, a warning to Spooner of the dead end he might be pursuing, but also a metaphor for Hirst's (and Foster's) predicament. Nevertheless, Spooner goes ahead and waits for his opportunity to request employment as Hirst's secretary, cook and butler (i.e. to effectively replace Foster and Briggs who, we have learned, fulfil all these roles). But this candid showing of his hand after all the game-playing and manoeuvring is, in its desperation, a confession of his having relatively little to offer. Spooner's gravest mistake is to offer Hirst an issue into society

with a public reading of his poetry in the upstairs room of a Chalk Farm pub. Not only is this an offer of creative regression rather than progression, but any attempt to reintegrate Hirst with literary society is doomed to failure because Hirst's redemption can no longer be achieved by the essential vanity of such pursuits. Perhaps Hirst is doing himself no favours by ultimately settling for the devil he knows, but, in writing Spooner out of his nightmare of the previous night ('I say to myself, I saw a body, drowning. But I am mistaken' (P3 399)), he is expressing that Spooner has no place in his house.

When Hirst shuts Spooner up by insisting that the subject has been changed for the last time, Foster takes command, suggesting that winter is the final subject and that 'it'll therefore be winter forever' (P3 396). The implied paralysis, conjured visually by having a bright summer's day shut out behind drawn curtains, is both Hirst's choice and his torment. This situation is the tragic thrust of the play: Hirst's emotional needs manifest themselves in the mutually exclusive impulses towards both change and stability, and this informs his responses to Spooner as a potential agent of change. The play functions dramatically, then, by first establishing an identification between the two men and eventually dislocating that identification with the flaws of individual self-interest and an indefatigable protection of the status quo. Foster and Briggs, as Hirst's servants and effective 'extended family' represent the forces of that status quo. Their protection of Hirst, though, is also his damnation as it perpetuates his no man's land of creative impotence. Hirst sadly comments that his home has not housed a free man for some time, and his servants' behaviour certainly suggests that they are as much his jailers as his aides. As both servants and masters, Foster and Briggs simultaneously represent 'other' and 'same' and their confrontation with Spooner, the 'other' who aspires to becoming 'same', is the central conflict that drives the drama as it seeks to resolve the simultaneous attraction and repulsion between the two old men.

This on-stage relationship between Hirst and Spooner provides visual and linguistic metaphors for some of the primary functions of consciousness: the simultaneous attraction and repulsion to and from 'other' as a source of individual identity and confidence. We recognize the characters' desire for

acceptance and affirmed identity set against a repulsion from the consequent paralysis such acceptance and affirmation might involve. These, after all, are the daily shifts and turns of our consciousnesses as they prop us up and propel us on. That we witness the waxing and waning of this very human dilemma between two men of retirement age, past their creative prime and with no promise of immediate release or fulfilment, reinforces the metaphoric fabric of the drama as it implies that the only release from such endeavour is death, which consequently renders the endeavour futile. All that is left is waiting, and a derelict no man's land.

A victim of the mysterious sleeping sickness *encephalitis lethargica*, Deborah in *A Kind of Alaska* (1982) actually personifies Hirst's no man's land 'which never moves, which never changes' and which 'remains forever, icy and silent' (*P3* 399). As such, she is a powerful dramatic discovery. But where *No Man's Land* was abstract and metaphysical, *A Kind of Alaska* provided a more concrete theatrical metaphor for human existential striving by voicing the clash between Deborah's waking and paralysed existences, and the confrontation of her reality with the realities of those who have cared for her. She too provides a definition of consciousness, one that is equally as claustrophobic as Hirst's 'icy and silent' jail:

> It's a vast series of halls. With enormous interior windows masquerading as walls. The windows are mirrors, you see. And so glass reflects glass. For ever and ever. (*P4* 189)

The character of Deborah was inspired by the case of Rose R in Oliver Sacks's book *Awakenings* which charts the treatment of twenty sufferers of the epidemic illness that reduced its victims to veritable statues, 'conscious of their surroundings but motionless, sleepless, and without hope or will' (*P4* 151). Each of these victims was temporarily roused from their condition by Sacks using the drug L-DOPA. Deborah is awoken by an injection given by her carer Hornby, and the play begins as she comes to and, filled with emotion, he watches and attempts conversation. Employing an evocative metaphor, she articulates her imprisoning experience as 'dancing in very narrow spaces [...] stubbing my toes and bumping my head. Like Alice' (*P4* 173). Now she must face the trauma of realizing that she is no

longer a teenager, and that her family is fragmented and unrecognizable. We only meet one of her sisters, Pauline, but learn that her mother is dead and that her other sister Estelle looks after their now blind father. Sadly, it seems, Deborah's death in life has infected the entire family with a similar sterility. We learn that Pauline had married Hornby eight years into Deborah's illness but that she considers herself to have been widowed by his dedicated attention to her paralysed sister. Even Estelle's spinsterhood and her father's blindness seem somehow connected to the illness.

As the play begins, Deborah and Hornby seem to occupy different spaces, until gently she comes to appreciate that, for once, her voice is being heard and she can slip into a synchronized conversation. She slowly and incredulously absorbs the information Hornby offers about her condition, and eventually makes her first significant stab at true liberation by stepping out of her bed, only to fall to the floor. Virulently rejecting all offers of assistance, she makes it to her feet to dance by herself in a supremely symbolic moment of absolute freedom. Seating herself at a table and caressing the table and chair, she seems happily alive once more, in command of her environment, absorbed by it. Only the appearance of an unrecognizable woman claiming to be her sister causes a fearful regression, and she returns to her bed where, later, she appears to suffer a seizure which causes twitching and the hunching of her back. As the play closes, she gratefully declares that she has 'the matter in proportion' (P4 190), but all she has managed to articulate of that proportion is a combination of some of the contradictory truths and lies she has been offered by Pauline and Hornby. Visually, then, the play provides a cycle of movement – from stillness to activity to stillness – as the trauma of paralysis is replaced by the trauma of apparently instantaneous ageing.

One might define existential anguish as the brief, accidental escape consciousness makes from the routine justifications it affects for the existence of the individual it serves. If these justifications are exposed as arbitrary constructions, all that remains is an awareness of the futility of all activity. Actual avoidance of all contemplation of this futility is therefore at the centre of the construction of identity. Our own confrontation

with *A Kind of Alaska* in performance can disturb us at this level and leave a sad and empty emotional residue, one that we cannot properly resolve in ourselves, but must assimilate or purge through interaction with others. This is typical of the compassionate humanity that is central to much of Pinter's more poetic dramas.

Dressed presumably in a white hospital gown or night attire, Deborah in her white coffin-bed is an acutely ghostly image and a precisely theatrical vehicle for Pinter's themes. Her condition embodies the fixity/progress dialectic within human interaction which he has pursued throughout *No Man's Land*, *Betrayal* and *Family Voices*, and her awakening presents an inescapable magnification of how the past informs the present moment as we seek to construct and clutch at identity. The temporal and mental distances she and her family have endured also neatly capture the difficulty of communicating felt emotion, a theme we have seen haunting characters in *Betrayal*, *Monologue* and *Family Voices* and which was to temper *Moonlight*. More than any other of Pinter's visuals, she is the perfect theatrical transport of multiple meaning, an artistic statement that only has true value when witnessed and heard upon a stage. The effectiveness of her symbolism is that it is at once realistic and metaphoric: not only do her words and actions match her predicament, but they are understandable and believable on that level. Moreover, somehow the release from her condition that we witness speaks for all of us in that it forms a recognizable shape of existential terror and resignation, the blinking mind coming to terms with a world that disappoints.

A little over a decade after writing *A Kind of Alaska*, Pinter offered an extended contemplation of mortality in a play suffused with death: *Moonlight* (1993). Two of its characters, Andy and his son Fred, are bed-ridden. Andy is clearly very ill and states that he is dying. Fred claims to be suffering 'a mortal disease' (*P4* 384). Their 'bedrooms' are separated from one another on-stage in areas defined by pools of stage light. In between is a third area of light, occupied by the mysterious character of Bridget, Andy's daughter. It is the emotional divide between family members, and their mechanisms for dealing with these, that serves as the focus of *Moonlight*. The play centres for the most part around the character of Andy who lies in bed

railing against his fate, verbally abusing his wife Bel and complaining that no one, least of all his sons, has come to see how he is. Indeed, the first quarter of an hour of performance is given over almost exclusively to an exposition of his character, not only in the manner in which he behaves, as a coarse, self-centred, attention seeker, but also in his and Bel's reminiscences and in Fred and Jake's discussions. Jake refers to him as 'a mountebank – a child – a shyster – a fool – a villain', to which Fred adds 'or a saint' (P4 332). Perhaps this retort is a tongue-in-cheek irony, shared between two dispossessed or self-exiled sons, but given the description of her parents that Bridget provides in her opening soliloquy we are made all the more aware of the discrepancy between the blunt Andy we are presented with, and the funds of care and affection he has in the past been able to expend. She informs us how Andy and Bel have dedicated 'all their life [. . .] all their energies and all their love' (P4 319) to her, Jake and Fred. Everything we witness and hear subsequent to this is qualified by it, leaving an undercurrent of spent emotion to all of Andy's ranting and Fred and Jake's embittered evasiveness.

Despite her relatively small role, the character of Bridget is the key to the play. Remove her and it would fold into a two-dimensional family drama. It is she who opens and closes the play, serving almost the role of chorus, speaking intimately with and directly to the audience. But her presence is a distinctly ghostly one. When Andy steals a drink against doctor's orders in the middle of the night and confronts her silent apparition in the growing moonlight, his shocked and despairing response is that of a parent for a daughter taken prematurely from him by death: 'Ah darling. Ah my darling' (P4 360). As the only scene in which Andy appears to the audience out of his bed and out of his stage area, the image it presents is memorable and significant. A dying man confronts, in the figure of his dead daughter, both his own past and his own mortality. In one brief scene the play is crystallized to its very essence: the weight of what has gone, coloured by veiled regret and stiff-lipped acceptance, and a fear of what is to come, with a consequent, painfully inaccessible need for reconciliation, recognition and unqualified affection.

Like the characters in *Betrayal*, those of *Moonlight* use

language to conceal and deflect buried seams of emotional need. Andy, in his bitterness, disdains love as 'redundant. An excrescence' (*P4* 333), but his bitterness is born of a need to distance himself from the painful frustrations that love instils. Theatrically, the experience of watching the play actually reflects this frustration as we switch between the emotional charge of Andy's deathbed scenes with Bel and the seemingly incomprehensible and sterile conversations between the two brothers. This dislocation can beguile an audience because of the hermeneutic gap it creates. In our confusion we wonder what exactly is going on in front of us, and share in Jake's exhausted query, 'What is being said? What is this?' (*P4* 366). Unable to comprehend anything the play might be 'saying', though, we are left vulnerable to the emotional charge it emits and the images of dislocation and separation it presents.

Moonlight is saturated with memories and references to the past as are many of the plays Pinter was writing twenty years previously. But here there are no disputes over possession of the facts of the past. Andy and Bel might each recall the infidelities of the other but there is little reproach vocalized as they do so, and no attempt to rob one another of memories, or rewrite them to gain any advantage. When the characters of Maria and Ralph appear, they serve not to rake up the extra-marital affairs they each engaged in with Andy or his wife, but to reinforce the themes of family and union, and thereby to further expose the rifts apparent between Andy and his sons. Addressing both the sons and the parents, and carrying no burden from their past infidelities, Maria and Ralph also strike a chord of potential reconciliation. They first appear with Jake and Fred, and seem to be attempting to convince them of their father's virtues as an open-hearted man and as a cultured thinker. When they later turn up together to see Andy in bed, they talk of the successes of their children, speak in a 'good old days' fashion of their youth together, and ask after Bridget. This, however, only inspires a protective resilience in Andy, who declares she has given him three grandchildren. Given Bridget's ambiguous stage presence, these grandchildren seem certainly an invention of Andy's grief and symptomatic of his refusal to come to terms with the hand he has been dealt.

As with so much of his more poetic drama, *Moonlight* affects

us not through the manner in which we engage with its characters as believable beings, nor through any accumulation of our understanding of plot or motivation, but because Pinter sets in motion the acutely recognizable shapes of our own experience. Recognition, though, is not a cognitive process here, but is akin to the recognition of defeat in an argument, or of joy in an embrace. It is pure emotion, provoked by dramatic scenarios and a poetic juxtaposition of word and image. In all of the dramas discussed in this chapter, the most common shape that this emotion forms is one of irreducible opposition, as frequently Pinter exposes us to irreconcilable opposing forces, like two repelling magnets being driven together but never capable of meeting. He expresses some of the principle dilemmas of our existence in this way, exposing the rifts between our private and our social beings, our emotional needs and the compromises they demand. In the 1980s and 1990s he would mobilize this ability emotively to evoke conflicting demands to make explicitly political statements, and his fascinations with staging the vicissitudes of consciousness and the appeal of the dead would have very different emotional ramifications.

Politics at Play

HOUSE RULES

'Don't let them tell you what to do', Petey feebly advises Stanley Webber in the last moments of *The Birthday Party* as Goldberg and McCann escort the latter out of the boarding house that is his home. 'I've lived that line all my damn life'[1] Pinter informed Mel Gussow in December 1988, reinforcing a statement he had made in the BBC programme *Omnibus* two months earlier to the effect that protest and subversion had always held a significant place in his drama. Though it is both difficult and facile to attempt to draw any significant parallel between Pinter's earliest writings for the stage and the later trilogy of plays which he wrote in response to implicitly political stimuli, it is clear that the anger and indignation that informed the writing of *One for the Road* (1984), *Mountain Language* (1988) and *Party Time* (1991) was responsible in part for plays such as *The Dumb Waiter*, *The Birthday Party* (both 1957) and *The Hothouse* (1958). And yet, Pinter's reappropriation of some of his earlier writings to his active human rights campaigning in the 1980s and 1990s might seem something of a *volte-face* given his insistence in the 1950s that he was 'not a committed writer, in the usual sense of the term, either religiously or politically'.[2] However, Pinter's earlier repudiation of any social framework to his writing ought to be considered in the context of the developments of the European stage in the middle of the century, a time when Bertolt Brecht's writings and touring were stirring up debates about the function of our post-war drama. Playwrights were increasingly expected to come down either on the side of the new dialectical, political drama that sought to dissect historical and sociological

models, or on the side of the avant-garde, those who would conjure allegories of the human condition. The argument was most notably illustrated in Britain by a series of open letters exchanged between the French 'absurdist' writer Eugène Ionesco and his harshest critic Kenneth Tynan in the pages of the *Observer* in 1958. Pinter felt comfortable in neither camp. He could never simply be accused of having placed characters in metaphysical isolation and, as Marc Silverstein points out, many of his early plays 'address themselves [...] to the vicissitudes of living within a specific cultural order rather than an incomprehensible universe'.[3] Equally, he was certainly not going to allow specific political interpretation to dilute and diminish the qualities of his own theatricality which, as we have seen, relied upon the qualities of uncertainty and ambiguity to achieve its communication. In many ways this was not to change when he came to write his most potent protest plays in the 1980s and 1990s, and a lack of specificity in these will be seen to serve a similar purpose.

Pinter's chief political concerns are essentially humanitarian; he is concerned with the relationship between the state and the individual and how the self-perpetuating concerns of the former often obscure and override the dignifying rights of the latter. He is interested in protesting the hypocrisy and complacency of those who wield power against those ill-equipped to respond, and is concerned dramatically to demonstrate how language is very often abused to mask political deviousness and overpower and demonize the underdog. Thematically, these matters form the kernel of many of Pinter's plays from both his early and later writings. Starting with *The Birthday Party*, it is possible to trace these concerns and examine their significance in the whole of Pinter's *oeuvre*.

In this play a listless outsider, Stanley Webber, who has clearly sought to retreat from society in a seaside boarding house, is tracked down by two figures from (or representing) his past. Once they have booked themselves into the house, Goldberg and McCann confront Stanley and subject him to an interrogation of mixed accusations and veiled threats. Their examination of him is interrupted and postponed to allow for a birthday party arranged for Stanley by his doting landlady Meg, with whom he shares an ambiguous relationship. The party

degenerates into Stanley's further humiliation and torment in the shape of a game of blind-man's bluff, from which he temporarily escapes in a murderous rage during a power cut. In the third act, following a night of further interrogation he returns, subdued and mute, and is led out to Goldberg's funereal black car to be carted off.

That the action of the play takes place on Stanley's supposed birthday is of key importance to the structure of the drama and much might be made of the ritualistic qualities and of the symbolism in operation within the game-playing and ceremonies around and during the party. As a formalistic device the fact of the birthday requires little more than passing lip service to establish itself. Stanley's protest that his birthday is not until the coming month, however, draws attention to the event as a social obligation that he would rather avoid, emphasizing a thematic concern. In his screenplay of Franz Kafka's *The Trial*, a novel of which Pinter was fond and which must have played some part in the intellectual genesis of *The Birthday Party*, Pinter opts to stress the fact that the two warders who wake Joseph K to arrest him do so on his birthday. For example, he has the screen hero find a pile of wrapped packages left on his desk by his staff at the bank where he works. This simple visual motif, not present in Kafka's novel, adds subtly to Joseph K's disorientation by emphasizing the social contract that a birthday implies, the terms of which are often decided by others.

This thematic and formalistic structure established by and around the notion and enactment of a birthday party provides an audience with a framework for appreciating the play in performance, but it gives us no rational framework by which to clarify for ourselves what message, if any, is being conveyed. We are given too few clues to satisfy our desire to know quite what Goldberg and McCann represent, nor why Stanley deserves their singular attention. He is clearly unnerved when he hears that two men are to be put up in the house, and the niggling dialogue between him and Meg in Act One significantly shifts to an expositionary conversation about his past, from which we learn that he had once held a career as a pianist until an aborted concert. Is it coincidental that this conversation, in which we hear of how Stanley had been 'carved up' and had refused to 'crawl down on [his] bended knees' (*P1* 17), comes so close to the

revelation that two mysterious men are descending upon his safe haven? As if closing crucial parentheses around the certainly misrepresented details of his past, Pinter has Stanley continue by teasing Meg about how 'they' are coming in a van to take her away in a wheelbarrow. This is a prophetically surreal rendering of his own sinister fate and perhaps also an indication that subconsciously he fears the arrival of his own bogeymen. Set in play is the notion of a shady past of rejection, recrimination and guilt. In his conversation, Stanley seems to have associated his apprehension at the coming of the two men with some unfinished business.

When we finally see Goldberg and McCann it is clear that they mean business. They confirm to each other that they are in the right house and we hear that they are there on a 'job', one which might be 'accomplished with no excessive aggravation' and the difficulty of which will depend on 'the attitude of our subject' (*P1* 24). These are clearly no holiday-makers and our suspicions are matched on-stage by Stanley's furtive avoidance of them. He is quickly reeled in though, and an audience's realization that these strangers represent a more significant thread to this drama than stories of flirtatious landladies and adolescent indolence is activated by implications that Stanley belongs to the same world as Goldberg and McCann. A number of associations are set up between the three men, initiated by Stanley himself. He attempts to suggest he and McCann have known one another previously, and that they had perhaps met in Maidenhead. He mentions the Fuller's teashop and Boots library there, defensively insinuating a middle-class respectability belied by his present shabby appearance. More striking, though, is his whistling 'The Mountains of Morne' along with McCann, the shared tune being more effective in binding the two in the audience's minds than any verbal motif. Though Stanley feebly attempts to invoke an affinity by extolling the virtues of Ireland and recommending a local pub that serves draught Guinness, his Jewish surname actually connects him more forcefully to Goldberg; a detail that can hardly be overlooked in a play in which characters refer to each other by name more than in any other of Pinter's works.

Once it is clear he is not going to win the two over, Stanley attempts to get rid of them by playing the stern landlord, but

Goldberg and McCann remain resolute. A battle of wills is established which deteriorates quickly into a veritable interrogation. Stanley is verbally whipped from both sides as both men begin to list the infractions for which he must atone. The assault merges two voices into a speech of the kind that abound in Pinter's writing. These frequently function as weapons of subjugation, placing the articulate speaker in a superior or menacing position. Mick's confounding use of legal terms to Davies in *The Caretaker*, Edward's preposterous list of alcoholic drinks offered to the matchseller in *A Slight Ache*, Briggs's description for Spooner of the one-way system around Balsover Street in *No Man's Land* all serve similar purposes. This interrogation, rather than the birthday party itself, is perhaps the central scene of this play, in that it serves to clarify characters' relationships to each other and the nature of the power struggle that is to be resolved. It is also where the play's chief concern, the oppressive forces of conformism, are most clearly articulated. Goldberg and McCann's job, it seems, is to make Stanley account for his guilt and to reassimilate him into some system or organization from which he has escaped. The details are necessarily vague, but the implications are perfectly clear. They begin by levelling general accusations of contempt for accepted social order at him (a rejection of his mother, leaving his wife standing at the altar, lechery, a dishonest trade), and stir these up to a frenzy with the demands of logic ('Is the number 846 possible or necessary') and nonsense ('Why did the chicken cross the road?' (*P1* 44 and 45)). Having already associated Stanley with McCann's Irishness and Goldberg's Jewishness, Pinter can now develop these into accusations of treason ('What about Ireland [...] What about Drogheda? (*P1* 45 and 46)' and atheism ('You stink of sin [...] Do you recognise an external force [...] When did you last pray' (*P1* 44)). A rejection of the essentially reactionary demands of church and patriotism, then, form the cornerstone of Webber's transgression. This Irishman and this Jew, representatives of two historically abused peoples and two ideologically inflexible religions, finish off by casting Stanley in the worst of moulds and follow through by suggesting his insignificance:

McCANN. You betrayed our land.
GOLDBERG. You betrayed our breed.

M<small>c</small>CANN. Who are you, Webber?
GOLDBERG. What makes you think you exist?
M<small>c</small>CANN. You're dead.

(*P*1 46)

That 'You're dead' carries with it the same weight as Lenny's conviction that the prostitute he brutalized was diseased merely at his say so (*The Homecoming*), or that assurance that the guard dog could not have bitten the old woman's arm because protocol would have dictated that it first give its name (*Mountain Language*). It is language used violently, illogically, as an oppressive force.

This interrogation, and the humiliation of the birthday party that follows it, is the central movement of the main action of the play. Peripheral to this and neatly framing it is the action between Stanley and his extended 'family' of Meg, Petey and their neighbour Lulu. One of the key attributes of this peripheral action is the sexual tension generated between Stanley and Meg, who delights at his use of the word succulent to describe her fried bread and, by extension, her. This interaction seems a perverse characteristic of her mothering role. We first question why she returns from having woken Stanley out of breath and rearranging her hair, and when Stanley later reprimands her, saying that she ought not 'come into a man's bedroom and – wake him up' (*P*1 12), the hesitation is provocatively placed, suggesting that he thinks twice about repeating details of the manner in which he was disturbed. Perhaps this subtle innuendo serves to underscore the latent guilt which Stanley is later forced to confront. That all this sexuality is passive, emphasized by Stanley's effete response to Lulu's vague come-on and Goldberg's subsequent seduction of her, seems to support this. Stanley's sterility and ineffectiveness are neatly conveyed in his 'washout' offer to take Lulu 'nowhere' (*P*1 20).

The concerns of the private and domestic that characterize the peripheral action are carried over into those of the public and social in the main action with a simple prop: Meg's birthday present of a boy's drum. Its stage presence acts as a visual umbilical cord between Meg and Stanley, for not only is it her gift to him, it is the gift of a mother to a child. As a replacement for his piano it might also represent regression, and a primitive

95

instinct for aggression is unleashed in his 'erratic, uncontrolled' (P1 30) beating of the drum on receiving it. Beyond Meg, it also connects Stanley to womanhood in general, as it is Lulu who brings the drum for Meg. When Stanley puts his foot through the drum skin during his turn at blind-man's buff, this hymen-breaking action might reflect his severing the ties of maternity and gentle sexuality, underscored by his attempted strangulation of Meg and physical assault of Lulu. This destruction, coming immediately after McCann snaps Stanley's glasses, seems also to be connected with that incapacitating action, and spells Stanley's imminent downfall.

A more elusive symbolic action is McCann's habit of tearing strips out of newspapers and then being peculiarly defensive of the result. Pinter, through Goldberg, seems pointedly determined to spell out that such behaviour, being 'without a solitary point' (P1 69), has no actual symbolic relevance. Its inclusion, nevertheless, is dramatically effective. The action puts McCann in control; the tearing produces an eerie stage noise that slows down the instant that surrounds it, drawing all on-stage and audience focus towards him. It is also wilfully destructive, and suggests a latent aggression that might be equally arbitrary. It also facilitates a remarkably articulate stage image that comes in the final minutes of the play. After having feebly attempted to give Stanley moral support, Petey lifts up his paper and strips fall from it to the floor. In this moment, the ineffectiveness of his protest and his own fragility, mirroring Stanley's, are eloquently evoked. The strips of paper strewn on the floor also reflect this family's shattered domesticity as we return to a brief exchange between the oblivious Meg and defeated Petey just as they appeared with the paper at the breakfast table when the curtain went up on them in Act One.

Dramatically, it is the hermeneutic vacuum left by a lack of clarity that holds our attention, and the paper-tearing and drum are symptoms of this. We can interpret poor Stanley's plight as the brutal demands of the adult world upon a reluctant adolescent forced to leave the family home, or as the oppressive conformism of political or religious ideologies, or as the inevitable pain of death that caps a futile existence, or even as birth itself – an expulsion from the Edenic womb – but while the play might point to all of these and other similar readings, it

does nothing more than evoke the 'shape' of such experiences. The word 'shape' covers the dramatic thrust of what happens precisely because it avoids the kinds of specificity that these interpretations impose and which Pinter's structures effectively avoid. It is the shape of active invading forces that diminish the resistance of latent desires and potentials, reducing these to obedience and conformity. It is the shape of unchecked authority that sneers at weakness and equates individuality with sedition. Our ability to recognize such structures in operation in our interpersonal relationships, in our society's infrastructure and in our country's political discourses provides us with a daily forum for ethical and moral consideration. Faced with such structures in ambivalent form on-stage, we are challenged on both emotional and moral grounds, and it is this thrust which lends works such as *The Birthday Party* a minor-key political sheen and provides the thematic link between what Keith Peacock distinguishes as the 'institutional' plays of the late 1950s and the 'state' plays of the 1980s.[4] Another such 'missing link' was unearthed in 1980 in the form of *The Hothouse*, the earliest of Pinter's plays to deal directly with abuse of the individual at the hands of the state.

Pinter's original decision to reject *The Hothouse* in 1958, only to patch up and present the play himself in 1980, is revealing. It demonstrates that the work played little part in the dramatic agenda he was pursuing early in his career, but that its concerns were too important to him to be left forever on the shelf. What made *The Hothouse* something of an anomaly for Pinter in 1958 are perhaps its rather explicit condemnation of the behaviour of its characters and the overtly political ramifications of the institution in which it is set. One of the strengths of *The Birthday Party* was that it left the implications of Webber's treatment and submission wholly open, and one can understand Pinter's original perception of *The Hothouse* as a flimsier sibling to his contemporaneous comedies.

The play is set in the offices and rooms of an establishment which is run on the approval of 'The Ministry', is equipped with sound-proof 'interview' rooms, and where corruption is clearly rife amongst the staff; a supposed rest home where patients are locked up, kept from their families, brutalized, raped and even murdered. At the head of this austere establishment is Roote, a

retired colonel in his fifties who, when we first meet him, comes across as either prematurely senile or irresponsibly unmindful of his duties. In the initial comic exchange between him and the officious Gibbs, we learn that one patient has recently died and been buried and that another has borne a child. From Roote's responses to Gibbs' questions there is a suggestion that he has been involved in both episodes. Most damning (and hilarious) is his memory that 6459, who has just given birth despite her lengthy confinement, 'wobbles in her left buttock' and that she 'like eating toffees, too...when she can get any' (P1 218), and the fact that he follows such convincing details of his acquaintance with the woman with an 'I don't think I know her' brush-off. The brutally clinical decisions to separate mother from child and find the father (i.e. accuse an innocent party) confirm the impressions we quickly pick up of the institution and its power structure. What is more, the offhand manner in which patients are dealt with as so much paperwork is disturbing. Not only is it alarming that they are referred to by numbers instead of names, but the details we glean of them are also disconcerting. 6457, we learn, had a limp and had prematurely grey hair, suggesting not only that perhaps he has been assaulted whilst 'in care' but also that he is rather young to have died of heart failure, his cause of death according to Gibbs. When we later learn that this patient had a mother agile and wily enough to get past the guards our impression is confirmed. This 'heart failure' smacks of the numerous dubious causes of death attributed to political prisoners and victims of corrupt policing the world over.

Any doubt as to the status of the so-called patients of this institution is quickly abolished when Roote declares that they are 'all people specially recommended by the Ministry' (P1 197). When he goes on to inform us that 'one of the purposes of this establishment is to instil confidence in each and every one of them' (P1 198), we have become adequately acquainted with the double-speak to conjecture just what is meant by that 'confidence'. It is the same logic that refers to a soundproofed interrogation chamber, equipped for torture, as an 'interviewing room'; the room in which we are to learn what is meant by that 'instil'.

The staff of this institution are a collection of self-serving bureaucrats, each bearing monosyllabic surnames that reinforce

the notion that they are merely a collection of one-dimensional pawns in some larger game, and Pinter does not dignify any of them with fully rounded personalities. Behind the ordered world of reports, invoices and lock-testing rounds lingers a network of back-stabbing and advantage seeking. Roote and Gibbs, who together open the play, are the two figures who offer the most intrigue to an audience, and the play specifically charts their progress: Roote's disintegration and Gibbs's rise to power. From their very first dialogue it is clear from Gibbs's astutely disguised insubordination that he does not hold his superior in any great regard and that Roote maintains his grip on control through verbal bullying. Lush is a far more cynical type and sees through the veneers of authority displayed by both his colleagues. As Roote's preferred drinking partner, he represents for Gibbs a risk to his succession to the role of superintendent. Lush also threatens Roote, running verbal rings around him in the opening dialogue in Act Two, and receiving whisky in the face in a farcical exchange where he insinuates Roote's culpability for the fates of both 6457 and 6459. The scene degenerates into actual brutality as we see Roote slowly lose his grip on power, control and sobriety. In a crucial moment in which Lush seems to question the absolute power which defines Roote's authority and justifies the existence of the establishment that employs them all, he apparently uncovers a deep insecurity.

ROOTE (*moving to him*). Explain yourself, Lush.
LUSH. No, you! You explain yourself!
ROOTE. Be careful sonny.
LUSH (*rising*). You're a delegate, aren't you?
ROOTE (*facing him squarely*). I am.
LUSH. On whose authority? With what power are you entrusted? By whom were you appointed? Of what are you a delegate?
ROOTE *hits him in the stomach.*
ROOTE. I'm a delegate! (*He hits him in the stomach.*)
 I was entrusted! (*He hits him in the stomach.*)
 I'm a delegate! (*He hits him in the stomach.*)
 I was appointed!

(*P1* 306)

This incident, which ends with Lush in a heap on the floor, reveals the pivotal nature of each character's motivations; they sway from an unquestioning deference to the state, embodied in

the statue of Mike out in the yard (and who replaces God in Roote's 'for the love of Mike' (P1 214)) to purely egotistical self-protection and self-promotion. Bleakly, it seems that the latter dominates and that even ideology is relegated to second place, becoming a convenient justifier of action. The futility and barbarity of such behaviour is neatly captured in the on-stage image of Roote, Lush and Gibbs each holding blades out-stretched at one another towards the end of Act Two. Ultimately Gibbs wins, benefiting from a total slaughter of the staff, which is ascribed to rebelling inmates but is equally likely to have been perpetrated by Gibbs himself. As he presents his report to a ministerial bureaucrat in the final scene, we are left with a reminder of the consequences of a system that permits the corrupt pursuit of power. The final stage image presents a picture of one of this system's forgotten victims:

> Lights rise on sound-proof room.
> LAMB in chair. He sits still, staring, as in a catatonic trance.
> Curtain.

> (P1 328)

With this sole exception – albeit of an employee turned scapegoat – Pinter offers us no glimpse of the underdog, of those who suffer at the hands of this establishment. This apparent gap ensures that the dramatic experience remains a comic one throughout. The offhand manner in which a birth and a death can be shrugged off, the ease with which relatives of the deceased can be fobbed off with untruths, the arousal that Miss Cutts and Gibbs experience from interrogating an inferior are all provoca-tively funny. Such details are also considerably sobering as we are reminded often enough of the invisible victims of these complacencies, which leaves a bitter aftertaste to each bout of laughter. Introducing these victims into the drama, however, might only serve to undermine any bite the play has, and it is the blackness of the farce that lends potency to any note of protest or warning that it offers. Presenting such detail would require another dramatic idiom, a more naturalistic and sympathetic one, if the political thrust of the play – the subjugation of the individual to state dogma – were to remain intact. The playwright was to employ such an idiom later. The allusions to Gila's off-stage rapes and her son Nicky's implied murder in *One for the*

Road (1984), for example, are far removed from the way in which 6459's rape and 6457's murder are presented.

IN THE NAME OF FREEDOM AND DEMOCRACY

Written four years after Pinter's own production of *The Hothouse*, *One for the Road* presents a starker dramatic examination of the goings-on within the walls of a similar institution: a place of internment where a dictatorial state might recondition its dissenting citizens before sending them, broken, back into its world. In four short scenes, we witness three members of a family being 'interviewed' by Nicolas, a man in his 40s and of high-ranking authority. The ironically named Victor, his wife Gila and their 7-year-old son Nicky have recently been arrested by soldiers in their home, which we hear was gratuitously vandalized in the process. We never discover what offence they are accused of committing, although the suggestion that they are intellectuals of some form ('He didn't *think*, like you shitbags. He *lived*' (P4 240)) seems to stand as adequate justification for the manner in which they clearly have been treated.

Both Victor and Gila show obvious signs of having endured violence and torture and we hear that Gila has had to submit to multiple rape at the hands of Nicolas's soldiers. It is clear that in his position Nicolas has absolute power over Victor and Gila's fates, a power he chooses to demonstrate by the seemingly pointless act of waving his index and little fingers in front of their faces. Their responses to him also indicate that whatever torture they have been put through has 'taught' them to do as he says. Within minutes of the play's opening, for example, Nicolas demands that Victor stand up and then, straight away, sit down again. Unquestioningly, Victor follows the futile request, to Nicolas's apparent satisfaction. Similarly, Gila agrees to change her version of how she met her husband when Nicolas reacts angrily to any suggestion that they could have met in a room also occupied by her late father, a man who had evidently been a significant figure in the status quo that Nicolas now represents. Such a reversal is a neat demonstration of the kind of honesty Nicolas and his establishment are there to induce in their enemies.

Visually, *One for the Road* presents differing images of power relationships, and these can remain in the memory long after we have witnessed a performance of the piece. The opening scene between Nicolas and Victor involves the traditional picture of victim seated and interrogator standing, reminiscent of many similar scenes in Pinter's writing where sitting is so frequently equated with submission. The second scene has Nicolas towering over young Nicky like some frighteningly dominant wicked uncle, and the third scene, in which he confronts Gila, finishes the symmetrical movement by having victim standing whilst interrogator is initially comfortably seated. These varying configurations occur not simply out of plain necessity (it would be rather boring to watch the same blocking repeated four times), they accentuate the power Nicolas can use and abuse freely to meet his ends. The image of a bruised woman standing in torn clothes and being forced to discuss her own rape, for instance, is particularly alarming. In a chair she might at least appear less isolated and feel more able to avoid her inquisitor's stare.

The power Nicolas commands over Victor and his family is being wielded principally to eradicate the risk that Victor and his like represent to the ruling élite. Nicolas explains that he has been given direct authority to deal with anyone that might oppose the policies of the government:

> Do you know the man who runs this country? No? Well, he's a very nice chap. He took me aside the other day [...] Nic, he said, Nic (that's my name), Nic, if you ever come across anyone whom you have good reason to believe is getting on my tits, tell them one thing, tell them honesty is the best policy. (*P4* 230–31)

The *raison d'être* of this establishment, then, is to enforce 'honesty' and Nicolas informs Victor that 'You have no other obligation' (*P4* 230). The inference, of course, is that honesty involves towing the party line and not 'questioning received ideas'.[5] Such twisting of words is reminiscent of Roote's objective of 'instilling confidence' in his patients in *The Hothouse*. It is evident from Victor's ragged appearance in the first scene that it has taken some effort on the part of his interrogators to get him close to appreciating the quality of the required honesty. Nicolas's job is to add the psychological dimension to the physical torment that Victor has suffered at the hands of his

lackeys. In this respect, Gila and Nicky represent for him tools of torture that can be applied to render his subject all the more malleable. This knowledge lends a sinister edge to lines such as 'What a good-looking woman your wife is' (P4 225) and the provocative 'Is your son alright?' (P4 228), and, once introduced to the other members of Victor's family, our fears are confirmed.

In his brief scene with Nicky, he does little more than question the boy's affection for his parents and scold him for kicking and spitting at his soldiers, and yet the conjunction of precisely these two aspects of questioning deposits a suggestion that the boy might expect a fate other than the death implied by Nicolas's charged observation: 'They [his soldiers] don't like you either, my darling' (P4 237). When Nicolas asks whether he would like to become a soldier, his question might not simply be a leader into berating the boy for abusing the soldiers who came to arrest his parents. Historically, from Bonaparte to Ceauşescu, it is not an uncommon practice for dictators to make soldiers of the orphans of victims, replacing their extant family structure with an all-providing patriarch in the form of the state. If the suggestion is purposefully embedded it is subtle, but any member of the audience who picks up the possible subtext to Nicolas's question to Nicky might experience a shudder at the ignominy of the absolute power at work here. We are certainly never directly told that Nicky has been killed, but are soon led to glean that he is as good as dead from Nicolas's suggestion that all concern for him is 'academic' (P4 244).

Gila's interrogation is lengthier and consists for the most part of a dialogue in which Nicolas seeks to establish where she and Victor first met. His objective, though, is not accessing the facts but breaking her will. Applying repeated, barked questions and non-sequiturs, he displays a perverse effort to terrorize her through an abuse of logic.

> GILA. I met him.
> NICOLAS. When?
> GILA. When I was eighteen.
> NICOLAS. Why?
> GILA. He was in a room.
> NICOLAS. Room?
> *Pause.*
> Room?

GILA. The same room.
NICOLAS. As what?
GILA. As I was.
NICOLAS. As I was?
Pause.
GILA (*screaming*). As I was!

(*P4* 238–9)

The effect of such a line of questioning is twofold: Gila must struggle against the barrage to maintain the version of events she remembers, in the process perhaps blurting out more information than she might if less pressured. She must also be fearfully aware of a need to supply a version of events that Nicolas desires to hear, and it is this fear that causes her to change her story and suggest that she met Victor in a street and not when together with her father.

This scene is in stark contrast to those between Nicolas and Victor. Nicolas states to Gila that he has no interest in her and he can plainly have Nicky disposed of in one manner or another. Victor interests him though, and his conversation with him has fewer of the hallmarks of interrogation technique apparent in his dialogue with Gila. Certainly, his goal is to incapacitate Victor's subversive potential in society, and this has clearly already been achieved to some degree. But his questioning goes further than his political objectives, and his almost convivial insistence that they share smalltalk and a glass of whisky (the 'one for the road' that Victor finally accepts) seems almost genuine, even if designed to disorientate and create unease. Victor's silence, though, is his greatest defence and an effect that provides the character with a fund of dignity that Nicolas has no hope of breaking. The representation of this dignity is crucial if the play in performance is to have any significant meaning beyond simple protest. It is reminiscent of the occurrence of silence as a tool of mediation elsewhere in Pinter's writing and specifically calls to mind the obduracy of Kullus in *The Examination*:

> I can only assume Kullus was aware, on these occasions, of the scrutiny of which he was the object, and was persuaded to resist it, and to act against it. He did so by deepening the intensity of his silence, and by taking courses I could by no means follow, so that I remained isolated, and outside his silence, and thus of negligible influence. (*VV* 86)

Victor's silence serves not only to isolate Nicolas (who is our key focus on-stage), it also creates a bond with the silent audience. His few utterances in the first scene also go some way towards indicating that Nicolas is 'of negligible influence', at least as far as Victor's rebellious spirit is concerned. Victor first refuses to be drawn into discussing whether or not he respects Nicolas and then responds reprovingly to the question as to whether his son is all right with a brief, repeated 'I don't know' (P4 228). His only other words in the first scene are the twice-repeated command 'kill me' (P4 232). Coming after a 'silence' (one of only five noted in the script), this request, provided with no qualifying adjectival quality, befits the dignity so far lent to Victor. It reduces Nicolas's conversation and recent ideological statements to so much prattle. It is an appeal to get to the point, to 'put up or shut up'. Nicolas can only respond by interpreting the request as simply a result of despair because to take it as a challenge would necessitate calling Victor's bluff and having him killed, an action that is clearly not on his agenda. Whether of despair or not, Victor's statement confirms to Nicolas that more work needs to be done on his prisoner to induce the adequately compliant attitude in him, and when Victor returns in the final scene his tongue has been cut or otherwise mutilated. Being also tidily dressed ready for his re-integration into society, he resembles the smart but inarticulate figure of Stanley Webber in the final scene of *The Birthday Party*. Like Webber, he now offers no resistance to his interrogator and responds to each question as best he can. Nicolas says he may leave and promises that his wife will be released the following week. In a final act of defiance, Victor asks about Nicky, only to receive this unequivocal response:

Your son? Oh, don't worry about him. He was a little prick. (P4 247)

This is the play's closing line, one that smacks of brutal finality, of powerlessness in the face of inhuman calculation. Its quality of offhand smalltalk deposits the play's final grain of outrage. If the curtain were to drop there, an audience would be left to pick up their programmes and leave the theatre carrying a burden of indignant, directionless anger. But the dramatic effect of unqualified anger is an inadequate one of preaching to the converted. It is extremely significant, then, that Pinter does

not actually close *One for the Road* simply with these final words, but with the stage direction for Victor to straighten and stare at Nicolas. There is then a 'Silence' followed by a 'Blackout'. Deposited in that protracted pause is a huge reserve of dignity, buttressed by Victor's attempt to stretch his aching body full straight in his chair.

As Victor stares Nicolas out, we are reminded of Nicolas's fascination with the eyes of his victims. In contrast to the vulnerability he claimed to see in them in the first moments of the play, he is confronted in the last moments by something beyond vulnerability. Whereas previously Pinter had often invested a metaphoric significance in eyesight (*The Room*, *The Birthday Party*, *A Slight Ache*, *Tea Party*), here there is an almost traditional, lyrical quality attributed to the eyes. When Nicolas says to Victor at the end of their first scene together that 'Your soul shines out of your eyes' (*P4* 233), we first become aware of the real goal of his torture, and these final moments of the play indicate it is one he can never achieve. Consequently, if this play has any 'meaning' as such, this is to be found in the charged interplay between Victor's gaze and how the actor playing Nicolas manifests the discrepancy between the character's power and his insecurities. The sharp blackout that punctuates the play's ending undermines Victor's dignity somewhat, but this is preferable to the potential that a slow fading of lights would have of softly romanticizing an image of human endurance. Caught suddenly in the darkness with our mixed emotions of anxiety, despair and that final blip of dignity, we might be partly purged by the applause that they ignite, but their residua remain to be resolved beyond the theatre walls.

Mountain Language is an even more bleak examination of absolute power; 'you have the army and you have the victims, there's no ambiguity there. It is crude',[6] Pinter admitted in 1993. The play is a short twenty-minute piece made up of four brief scenes set first outside and then within prison walls. The first scene quickly establishes the political environment of military repression. A line of women have been left to wait in the cold and snow for eight hours before they may visit their incarcerated sons, fathers and husbands. An old woman has been bitten by a Doberman Pincher in an incident where the women have been intimidated by guards with dogs. An officer arrives and

dismisses the wound by asking for the dog's name, absurdly insisting that his dogs have orders to give their names before they bite. He then announces the rules by which the women must abide once admitted into the prison:

> Now hear this. You are mountain people. You hear me? Your language is dead. It is forbidden. It is not permitted to speak your mountain language in this place. You cannot speak your language to your men. It is not permitted. Do you understand? You may not speak it. It is outlawed [...] This is a military decree. It is the law. Your language is forbidden. It is dead. No one is allowed to speak your language. Your language no longer exists. (P4 255–6)

This list of accumulating tautologies reveals the ruthless absolutism of the regime in power, as well as the ironic lifelessness of the language of authority. Depriving a people of their mother tongue is the most effectively suppressive act of control over that people, and indicative of an intolerant, even genocidal logic. Here is the kernel of Pinter's concern: the state oppression of ethnic identities (or any minorities) that do not conform with the visions of the ruling ideology. The consequences of such brutal logic are played out in the following scenes in which we witness the separation of two couples: the old woman and her son, and the young woman and her husband.

In scenes two and four we see the old woman with the bitten hand, her son the prisoner and a guard. In the first of these scenes the mother is jabbed by the guard each time she begins to speak the mountain language. Unable to understand the language in which she is being rebuked, she only repeats her error and receives further abuse. In his desperation and anger the prisoner provokes the guard's fury, who reports to the sergeant that he has 'a joker' (P4 260) on his hands. This 'joking' has obviously been excessively punished prior to the fourth scene as the prisoner is visibly trembling when we next see him, and ends up shaking in a violent fit on the floor. His anguish has deepened as he has been unable to convince his mother that a relaxing of the rules now permits them to communicate temporarily in their own language. This is perhaps the most pitiable image in the whole of Pinter's work: a broken man, prostrate on the floor and shaking from the extreme psychological duress he has had to endure; his silent, terrified mother helpless beside him. We are offered no dramatic respite. The

image is followed by the entrance of the sergeant and the closing line of the play:

> The SERGEANT *walks into the room and studies the* PRISONER *shaking on the floor.*
>
> SERGEANT (*To* GUARD): Look at this. You go out of your way to give them a helping hand and they fuck it up.

(*P4* 267)

As a closing sequence this is about as unambiguous, as crude a statement as Pinter can make. His rage is undeniable and is powerfully conveyed to his audience. No dignity has been afforded the old woman and her son, finally stripped of the utility of their mother tongue.

If the play has any redeeming grain of hope this is to be found in the spirit of the young woman who appears in scenes one and three. She has come to the prison to see her husband who is being kept 'in the wrong batch' (*P4* 257) with the mountain people. As she separates herself from the line of shivering women in the opening moments of the play, first to speak for the old woman whose hand has been bitten, and then to complain at the length of time they have all been kept waiting, she becomes an immediate focus for the audience's attention. We invest our faith in her because she dares to stand up to the uniformed thugs, albeit without any palpable effect. Setting her apart as a troublemaker, her behaviour also ensures that she attracts the unwanted attention of the sergeant, who attempts to quash her anger by placing his hand on her bottom and making veiled threats, firstly to her freedom (by replying 'so is she' (*P4* 257) to the officer's observation that her husband is in the wrong place) and then to her person through his manhandling and repeated reference to her sexuality. The scene finishes with an ominous combination of insult, innuendo and threat that utterly incapacitates the woman's protest: 'Intellectual arses wobble the best' (*P4* 257). The line caused some controversy, and reading it off the page one can understand why. Hearing it off the stage, though, coming from the mouth of an antipathetic sergeant, the effect is appropriately unpleasant. He is implying that he can be sexually aroused all the more by an intellectual, supposedly because it might be more gratifying to overcome an articulate woman, and thereby put her 'in her place'. Given his position of

acquired superiority, not to mention his almost certain physical superiority to the woman, it is a calculatedly ill-disguised threat of violation or a statement of the easy accessibility of such a threat (like Nicolas in *One for the Road* he can easily overlook any rape another might inflict). The audience is robbed of witnessing any response the young woman might offer by an abrupt blackout that closes the scene. The sudden darkness, the hushed silence in the auditorium around us, the stage image still burning on our retina and the words fresh in our head all leave us complicit with the sergeant's final remark. We are shamed further, perhaps, by any recognition of the humour in the statement. Dramatically, it is a precise evocation of the unquestionable power of the military, and the hopelessness of the citizens in the face of this arrogant assuredness. By denying the young woman the dignity of a response, even a facial one, Pinter is displacing that response out into the very audience he is also implicating as complicit. It is a precisely calculated moment that deposits shame, despair and rage in us.

That the young woman deserved to be put 'in her place' at all is merely because she had the nerve to point out an administrative blunder that caused her husband to be placed in amongst the mountain people. The description 'intellectual' is applied to her by the sergeant not only as an insult but as a threat, in that it might well indicate what misdemeanour probably led to her husband's incarceration: unlike the mountain people who are being punished for not speaking the language of the capital, this man might well have been locked up for voicing the 'wrong' thoughts with the 'right' language.

In scene three the same young woman is informed by the same sergeant that, due to a computer error, she has found her way through the wrong door and needs to arrange an appointment with a Joseph Dokes to answer any enquiries she might have. When she asks: 'Can I fuck him? If I fuck him, will everything be all right?' (*P4* 264), she indicates that she has understood the currency of negotiation implied in that earlier threat. Placing herself as the active subject of the verb instead of its vulnerable object, her question is both infuriated and sarcastic in tone, and is therefore effectively subversive. In this way, by apparently adopting the mind-set of those in power, she makes her strongest protest.

Mountain Language is perhaps Pinter's most forceful protest play. The crudity of the power being wielded and the hopelessness of its victims allow none of the dignity that Victor can at least muster in *One for the Road*. Instead, their humanity is allowed expression by the insertion of dream-like, almost lyrical, voice-over passages into an otherwise naturalistic dramatic world. Accompanied by appropriately differentiated lighting states, these passages provide the audience with breathing spaces within the otherwise relentless images of irrepressible cruelty, and perhaps serve also to suggest the indissoluble quality of the human spirit. They represent the thoughts that cannot be invaded by the military thugs ('They have bitten my mother's hand' (P4 261)) and add depth to characters that risk demeaning two-dimensionality in this terse drama, providing backgrounds of familial affection and hope: 'The baby is waiting for you [...] When you come home there will be such a welcome for you' (P4 261). In the exchange between the young woman and her husband the unashamedly romantic recollection they share of love out on a lake in the spring is in sharp contrast to the stage image of a brutalized man wearing a black hood. These might be the voices of an enduring, romantic spirit, but the contexts that frame them are intolerably dispiriting for an audience. The scream of the woman as her husband falls exhausted to the floor immediately the stage lights return them from their voice-over passage is concrete and desperate, and shocks us back to reality. Rather than reinforcing any hope, then, the dramatic function of the passage seems to be that of deepening our despair at the plight of these everyday people turned victims.

Party Time, by contrast, sought to provoke our irritation at the mentalities of the ruling élite who, in their anaesthetized worlds, can deem necessary the plights of such victims. Set at a party hosted by the amiable Gavin, the play presents a select group of people who, having circumnavigated roadblocks and driven through streets emptied by curfew, have come to hobnob with the their upper-class equals and ruling betters. The principal subject of conversation is their membership of an élite health club. Rather than facilitating any keep-fit activity, though, this club provides comfortable social environments and luxuries such as a pool-side bar, hot towels and *haute cuisine*, all delivered

with a 'gold-plated service in all departments' (*P4* 310). Membership of this club is worn like a piece of jewellery, a badge of exclusivity, and at first this seems at one with the morally redundant 'society of beautifully dressed people' (*P4* 299) that Pinter is parodying. Eventually though, as the play progresses, the club is equated more directly with the ideology of the ruling party. Its exclusivity ('they don't let any old spare bugger in there' (*P4* 283)) clearly matches the ruthlessness with which political opposition is being quelled out in the streets: 'People don't do vulgar and offensive things. And if they do we kick them in the balls and chuck them down the stairs with no trouble at all' (*P4* 310). Ethical and ideological rhetorics ultimately merge to engender a sinister doctrine to which it is clear almost everybody present subscribes. This is articulated by the ageing Dame Melissa as she addresses the gathering to eulogize over the qualities of their health club. As she does so we gain an understanding of the fate of the previous administration:

> The clubs died, the swimming and the tennis clubs died because they were based on ideas which had no moral foundation, no moral foundation whatsoever. But our club, our club – is a club which is activated, which is inspired by a moral sense, a moral awareness, a set of moral values which is – I have to say – unshakeable, rigorous, fundamental, constant. (*P4* 311)

This is the kind of righteousness articulated by political leaders the world over to exonerate their political machinations. Historically, this spirit has always been fortified by a religious veneer, by which acts of repression, war and genocide can be vindicated by the obscurity of divine purpose. Goldberg (*The Birthday Party*), Roote (*The Hothouse*) and Nicolas (*One for the Road*) manifest this religious fervour: 'Do you recognise an external force, responsible for you, suffering for you?' (*P1* 44) demands Goldberg; 'Are you a religious man? I am. Which side do you think God is on?' (*P4* 224) taunts Nicolas. Here the same vocabulary of higher morality is being applied, though as the party progresses we learn how each of these characters is riddled with moral ambiguity and hypocrisy. The public gloss that Douglas paints of Liz as a good wife and mother, for example, is undermined by our knowledge of her infatuation with another man, and the viciousness she displays when

talking of the woman who seduced her would-be lover. Most notably, though, Dusty's insistence on knowing what has become of her brother Jimmy provides us with the crucial clues to the nature of the regime in power. Evidently it is one that causes people to disappear, and no amount of moral high-talk can disguise that. Each time Dusty attempts to raise the issue, she is reminded by her husband Terry, obviously a hard-man lackey of Gavin's, that 'nobody is discussing this' (P4 284). She causes him such embarrassment, evinced when Gavin puts a conversational snub his way, that he takes her aside and silences her with threats: 'you're all going to die together, you and all your lot' (P4 302). His statement hints at a genocidal agenda, but is all the more alarming in the context of the sexual titillation that the couple gains from their conversation. The brief detail of this sado-masochistic relationship in which power and death threats are currencies of arousal not only adds a further touch of vacuous decadence to these people, it despairingly negates any effective voice of protest that Dusty might represent. Instead, Charlotte provides a neat challenge to the orthodoxy at work when, after realizing that her ex-lover Fred is implicated in the death of her husband, she queries his morality:

> You're still so handsome! How do you do it? What's your diet? What's your regime? What *is* your regime by the way? (P4 307)

Pinter drives his point home quite forcefully by a shift in dramatic idiom that permits Dusty's brother Jimmy to appear on-stage in the final moments of the play and give an incoherent but nevertheless succinct account of his treatment behind locked doors. There are no specifics, but there is clear evidence of psychological damage and solitary confinement:

> When the terrible noises come I don't hear anything. Don't hear don't breathe am blind [...] I see nothing at any time any more. I sit sucking the darkness (P4 314).

The dramatic effectiveness of the protest that Pinter conjures resides in the fact that the anger that plays such as *One for the Road*, *Mountain Language* and *Party Time* manage to lodge in their audiences has no apparent immediate objective: we do not know at whom we ought to be directing that anger. The societies on-stage have not been named, and we have difficulty

recognizing the laws and military as being those of our own country. Certainly, it is no secret that *Mountain Language*, for example, was written as a response to the treatment of the Kurdish population by the Turkish government, but by avoiding specific reference Pinter draws attention to the general fact that such abuse is meted out on ethnic groups in numerous countries, and the political zeal that causes and justifies it might be ignited anywhere. In this way, rather than asking us to condemn a specific political situation in a given country, the play invites us to consider the relevance to us of what it is presenting, soliciting a rational and ethical response to an extreme emotional experience.

Effectively, Pinter has harnessed the potency of ambiguity so often employed in his earlier writings, and used this to craft political parables that can be universally applicable. In this sense the protest is not only against the actual atrocities carried out by questionable regimes abroad, but serves as a warning of how the persuasiveness of ideological conviction can have consequences much closer to home. Consequently, each of Pinter's 'political' plays shares an intent to alert us to the fact that political corruption can be at work closer than we like to think. With character names as quintessentially English as Sara and Charley Johnson, *Mountain Language* seems to suggest that its action takes place in modern-day Britain. When the play was directed by Pinter at the National Theatre in 1988, his decision to clothe the sergeant and officer in contemporary British military uniforms starkly reinforced that suggestion. Nicolas in *One for the Road* talks in cricket metaphors and paraphrases Shakespeare's *Hamlet*, and the image of refugees being drowned off the coast of Dorset in *Ashes to Ashes* is purposefully unequivocal. In *Party Time*, Pinter evokes a London of curfews and blockades bypassed by an élite who can shrug off the atrocities carried out in their name.

Like many, Pinter was disaffected by the creeping restrictions placed on civic freedom by the Conservative government of the 1980s. Clause 28, which attempted to limit the teaching of literature deemed homosexual, was symptomatic of a reactionary political scapegoating that, in turn, was to victimize diverse minorities including the jobless, travellers and single mothers. The 1986 *Spycatcher* scandal, in which Peter Wright was banned

from publishing his memoirs of MI5, revealed the absurdly draconian nature of the ever-tightening Official Secrets Act. Pinter perceived that the gradual increase in police powers over a number of years, including the provisions of the Prevention of Terrorism Act and the 1992 loss of the right to silence, had nothing to do with 'democratic aspirations', but was aimed at 'the intensification and consolidation of state power' (*VV* 174). The warnings encapsulated in his plays were becoming, it seemed, all the more pertinent. Even if *One for the Road* and *Mountain Language* did not necessarily dramatize the behaviour of the British government and military, they are potent insinuations of the direction in which certain measures, readily justified and apparently necessary, might ultimately lead. By placing his protest plays in environments that might so easily be modern Britain, Pinter suggests that repressive zeal is not the discourse solely of military and fascist dictatorships, but is in operation in the corridors of power of all Western democracies, those self-proclaimed pioneers of a just New World Order.

It was the enthusiastic talk of this New World Order in the wake of the Gulf War in 1990 that inspired Pinter to write a sketch that once again warned of the potential consequences of such enthusiasm. *The New World Order*, written in 1991, is ironic in tone and blends black humour with its grim implications. Again, torture is the theme as we are introduced to Des and Lionel discussing the work they are about to commence on a silent, blindfolded man sitting (of course) in a chair in front of them. Later, we learn, they are to deal with his wife. It is as though we are gaining a glimpse of Victor's backstage treatment, at the hands of another Goldberg and McCann couple. Like Victor, and Sara Johnson's husband, this man is an intellectual, a lecturer of theology (Lionel guesses), and his crime was to have 'never stopped questioning received ideas' (*P4* 276). The majority of the five-minute sketch involves Des and Lionel discussing the man as though he weren't there, but with the clear intent of terrifying him. Before torture commences Lionel breaks into tears, and confesses he is emotional because of the purity of his work. 'You're keeping the world clean for democracy', Des says supportively, and then closes the sketch by gesturing towards their victim and stating: 'And so will he ...' (*He looks at his watch*) ... in about thirty-five minutes' (*P4* 278).

114

The thrust of the brief sketch is in this punch line. The use of the word 'democracy' here might serve partly to inculpate those regimes which connive to mask their inhuman schemes behind a veneer of democratic government. In conjunction with that most media-friendly of terms 'New World Order', however, it would seem that Pinter wants to warn us to consider that which is being done in our name by our own governments. The Gulf War of 1991 served to illustrate the force, language and hypocrisy of the so-called New World Order, an ideology that, following the timely demise of the Cold War, purported to have the basic tenets of freedom, democracy and human rights as its motivating factors. Pinter was concerned at how easily such a vocabulary of morality can be exploited to cover, justify or even drum up support for foreign policies that might restrict freedoms and occasion innocent deaths:

> I think there is a gap between reality and the language used about it, a tremendous gap, an abyss in fact. I wondered whether Mrs Thatcher, for example, has ever thought about what it is actually like to be tortured. I think very few people are encouraged to do that.[7]

Through the character of Douglas in his 1991 play *Party Time*, Pinter criticizes such double-speak in the application of brutal terms to the goal of achieving peace:

> We want peace and we're going to get it. But we want that peace to be cast iron. No leaks. No draughts. Cast iron. Tight as a drum. That's the kind of peace we want and that's the kind of peace we're going to get. A cast iron peace. *He clenches his fist.* Like this. (P4 292–3)

The implication is clear that by 'peace' we are to understand the entrenched, inexorable power of the state enforcing its own values so that 'normal service' can be provided to 'the ordinary citizen' (P4 313). It was nominally for the sake of achieving peace that the United States and its allies sought to enforce United Nations resolutions upon the Iraqi forces for having invaded Kuwait in 1989. A decade later, the NATO bombing of Yugoslavia seemed to reach excessive levels of destruction in an attempt to release the tormented ethnic Albanians in the Yugoslav province of Kosova from the abusive machinations of the Belgrade government. Operation Desert Storm and Operation Allied Force introduced us to distanced TV wars where 'surgical bombing' ensured minimized risk (to allies) whilst

effecting maximum damage. Oxymorons such as 'friendly fire' and euphemisms such as 'collateral damage' became shoulder-shrugging components of bar-room conversations in which the pros and cons of war could be nonchalantly discussed. A backdrop to all this, daily news bulletins showed video footage of the cross-thread accuracy of 'intelligent weapons' backed by the complacent bravado of military and political leaders. Here was the cutting edge of the New World Order, and the West's stand against the vicious Ba'ath party's regime in Iraq or the ethnic cleansing policies of Slobodan Milosević were perhaps the first, most significant tests of the strength of its rhetoric, as embraced by both politicians and the media. During both crises, Pinter was active in criticizing all incidents of hypocrisy disguised by such rhetoric. If the allies in 1999 were bombarding Serb targets as a result of 'humanitarian considerations', for example, why, asked Pinter, do they not intercede in the 'appalling repression of the Kurdish people in Turkey' where 'many thousands of people confront substantial and persistent persecution'.[8] Why, he asked, do they not reconsider their policy of sanctions against Iraq, sanctions which have been directly responsible for the deaths of 'nearly one million Iraqi children. That's genocide for you – in no uncertain terms.'[9] If morality is to be evoked as the prerogative of a New World Order, then an unambiguous moral centre needs to be established against which all action might be measured.

Celebration (2000) subtly deposits a disturbing suggestion that the 'peace-keeping' foundation to our New World Order has become an abused term and smokescreen for imperialistic power strategies. 'Strategy consultants' [...] Worldwide. Keeping the peace'[10] is the given occupation of the foul-mouthed, brutish Lambert and his brother-in-law Matt, who drunkenly enjoy a meal with their spouses in supposed celebration of the former's wedding anniversary. Like the self-congratulatory élite of *Party Time*, the group of people gathered in this restaurant, speaking vacuously of the delights of food and copulation, seem to conjure up the powerful minority happily steering the course of the new Europe and redefined global power network at the end of the century, and the satiated middle classes who obliviously disregard any displacements in power. Written and performed at the shift of the millennium, when global

celebrations focused on the notion of past achievements and future aspirations, the play provided a subtle and careful warning in the sinister intimation that, for the peace-keepers, there are 'plenty of celebrations to come. Rest assured'.[11] The surreal interjections of the waiter, who sums up the artistic and political tapestry of the twentieth century through recounting the impossible acquaintances of his grandfather, provides a more human backdrop to the gluttony and gloating. His final lonely speech is reminiscent of that of Jimmy at the end of *Party Time*, as he stands, emblematic of the forgotten multitudes, victims of the machinations of the few, stuck in the middle of 'the mystery of life' and not able to 'find the door to get out'.[12]

A system that might equate to any New World Order is outlined in a question flung at the hapless Lamb during his interrogation at the end of Act One of *The Hothouse*:

> Do you feel you would like to join a group of people in which group common assumptions are shared and common principles observed? (P1 252)

and Nicolas in *One for the Road* revels in an ecstasy inspired by the absolute order that such 'common assumptions and common principles' can inspire:

> I feel a link you see, a bond. I share a commonwealth of interest. I am not alone. I am not alone! (P4 232)

He equates this longing for order with patriotism, and his treatment of Victor stems from a dutiful and certainly heartfelt belief that the social order needs to be upheld at all costs. But Pinter is frequently at pains to demonstrate that such conviction is constructed only of the pervasive discourses of power, and he often does so by showing the cracks in the logic. Goldberg who, like Nicolas, achieved his position by doing as he has been told ('Follow the line', he recommends to McCann, 'I sat where I was told to sit' (P1 71)), shares an insecurity with that character. In Act Three of *The Birthday Party* he begins a sentence that he finds impossible to finish:

> Because I believe that the world (*Vacant.*)
> Because I believe that the world (*Desperate.*)
> BECAUSE I BELIEVE THAT THE WORLD (*Lost.*)
>
> (P1 72)

This void where faith and conviction should supply con-
fidence suggests that Goldberg and McCann are perhaps not
immune from the machinations of the system they serve. Gus in
The Dumb Waiter certainly learns this lesson. It is also the fate of
Roote and might well be of Nicolas, or of the officer who clearly
irritates his sergeant in *Mountain Language*. In this way, Pinter
implies that the structures of power are nothing more than
arbitrary constructs, upheld only by adherence to their dictates.

Throughout his political plays, Pinter sought to demonstrate
that the seemingly innocent desire to belong to a group and play
one's part in an ordered society can never be wholly free of
political exploitation, and that the impulse to participate and the
comfort of sharing ethical values can easily degenerate into
the rejection and castigation of those who dare to question the
motives behind that participation and the basis of those ethical
values. During both the Falklands conflict and Gulf War, for
example, the ignominious insult 'unpatriotic' was traded in the
House of Commons and in the pro-war British media in
attempts to stifle any humanitarian concern for the conse-
quences of the deployment or behaviour of British and US
forces. Such an effective yet ultimately empty word can have
dire consequence in political environments where freedom of
expression is restricted. It is an example of what Pinter describes
as 'language [...] employed to keep thought at bay' (*VV* 197). In
a brief sketch, *Precisely*, written for an anti-nuclear review in
1983, the character of Roger states that he would like to put those
who are spreading exaggerated accounts of the potential death
toll of a nuclear war 'up against a wall and shoot them'. 'As a
matter of fact, I've got a committee being set up to discuss that
very thing' (*P4* 216–17), responds Stephen, his drinking partner.
In *The New World Order* a joke is made of the repression of a free
press:

> DES. [...] After all, he's read the papers.
> LIONEL. What papers?
> *Pause.*
> DES. You're right there.

> (*P4* 273)

Such repression can always be justified by a righteousness
constructed wholly of rhetoric, of which 'keeping the world

118

clean for democracy' is a prime example (*P4* 277). Such righteousness is often also mobilized to identify the enemy by constructing moral codes that separate 'us' from 'them'. Consequently, the persecution of victims often involves processes of devaluing or dehumanizing them and language, again, plays no small part in this process. Pinter demonstrates this repeatedly. In most cases it involves verbal abuse through which the victim is reduced to scatological, bestial or sexual levels: 'They are enemies of the State. They are shithouses' (*P4* 255) is the description given of the prisoners in *Mountain Language*, and Nicolas says of Victor: 'morally... you flounder in wet shit' (*P4* 227). In *The New World Order*, Des downgrades a lecturer of theology to peasant status, playing with the words to create an insult: 'lecturer in fucking peasant theology' (*P4* 273). In this way persecution is doubly justified through a reductive classification of the victim. That the guard's fury in *Mountain Language* can be provoked by any suggestion by his prisoner that their lives are of equal worth (the equation in which they both have a wife and three kids) is indicative of this kind of thinking, where repression requires the alienation of a distinct group of people. Indeed, the writing of *One for the Road* was inspired by an incident in which Pinter quizzed Turkish guests at a party about their views on torture in their country. He was horrified by a response that intimated that any detainees deserved whatever punishment they received because 'they were probably communists'.[13] In *Precisely* Pinter crudely equates that political allegiance with its gruesome fate at the hands of intolerance in a conversation where Stephen and Roger discuss the entrails of their hated journalists as being the 'same colour as the Red Flag' (*P4* 218).

Perhaps Pinter seeks to extricate socialist impulses from the rubble of propaganda with which an essentially right-wing (i.e capital driven) world view has attempted to bury them. Claiming that 'socialism can never be dead because these aspirations [to alleviate these unforgivably degraded lives] will never die' (*VV* 193), he has often sought to expose the New World Order as being the actual manifestation of US foreign policy, which he pithily defines as 'kiss my ass or I'll kick your head in' (*VV* 181–2). Whilst all the time deploring the atrocities committed by dictators in totalitarian regimes, some of Pinter's

most articulate attacks during the 1980s and 1990s were upon the fatal consequences of this foreign policy on the civilian populations of, for example, Cuba, the Dominican Republic, East Timor, El Salvador, Grenada, Guatemala, Indonesia, Iraq, Nicaragua, Palestine, Serbia and Turkey. That successive British governments have toed this same line evidently sticks in his throat. Pinter considers that tolerating civilian deaths in their millions, as incidental to the claimed pursuit of 'freedom, democracy and Christian values', must involve a 'disease at the very centre of language, so that language becomes a permanent masquerade, a tapestry of lies' (*VV* 182). Ronald Knowles contends that it is 'ironic that the values Pinter would most support [. . .] are those of the Constitution of the United States, which derive [. . .] from the values of the Enlightenment – freedom from any form of oppression, liberty of conscience, and equality before the law – in a word, democracy'.[14] This, in itself is an abuse of language; an apologetic critical smoke-screen that misrepresents Pinter's outrage by deflecting its focus. Crucially, it is precisely the nature of that democracy that Pinter so forcibly questions. He does this by attempting to expose the suffering hidden behind the rhetoric of freedom and democracy:

> I feel a lively interest in the dead. I'm speaking here of the political dead. I wrote an article [. . .] about the United States, about what they have done, the number of deaths in the world for which they have been responsible, in their millions. [. . .] At the end of this article I wrote something like: 'But the dead are still looking at us, steadily, waiting for us to acknowledge our part in their murder.' By 'we' I refer to the unbelievably arrogant discourses of those who claim to speak on our behalves.[15]

Where else might one awaken the outraged dead and give them voice than on a stage? Theatrical characters, after all, are non-living entities, trapped between the pages of their play texts. We speak of their being 'brought to life' by our actors, but actually it is our recognition that ignites their life. We recognize them as aspects of ourselves and of the world in which we live. It is precisely this focus upon the dead that serves to distinguish Pinter's later political plays from his earlier, quasi-political writings. In *The Birthday Party* and *The Hothouse* we witness the process of victimization and coercion and are partially inculpated by the laughter we are permitted. With *One for the Road*,

Mountain Language and *Party Time* it is now 'past a joke'[16] and we see the utter despair and hopelessness of the victims. These are the dead that Pinter asks us to face 'because they die in our name. We must pay attention to what is being done in our name' (*VV* 182). Coexisting in society brings with it a set of mature responsibilities. If theatre has any significant function other than the aesthetic, it is its capacity to sharpen our awareness of these responsibilities. What better gauge might we apply to assess the worth of Pinter's committed theatre?

4

Efficient Ideas

The germ of my plays? I'll be as accurate as I can about that. I went into a room and saw one person standing up and one person sitting down, and a few weeks later I wrote *The Room*. I went into another room and saw two people sitting down, and a few years later I wrote *The Birthday Party*. I looked through a door into a third room, and saw two people standing up and I wrote *The Caretaker*.[1]

Flippant and evasive as it might sound, this is about as accurate a description of Pinter's creative process as he has ever felt able to make. It is nevertheless extremely revealing. Each of Pinter's plays seems to be constructed around a single premise. Each has some crisis, imbalance or mystery that its entire dramatic momentum is geared toward resolving or revealing. If a director, actor or, ultimately, a spectator wants to discover the kernel of any of these plays, they might do worse than contemplate the primal situation which gives rise to all of the words and action. Pinter's descriptions of the geneses of many of his plays are remarkably consistent with one another. As in the above example, he often states that he starts with an initial image or snatches of conversation that strike him as particularly loaded and then, he claims, allows things to follow their own course:

I have usually begun a play in quite a simple manner; found a couple of characters in a particular context, thrown them together and listened to what they said, keeping my nose to the ground (*VV* 17).

The word 'found' here is pertinent, in that whatever spark first ignites Pinter's passion to write, it always comes by way of unexpected inspiration. *Old Times* and *No Man's Land*, for example, both came into being from sudden bursts of inspiration that struck him, respectively, whilst reading a paper on a sofa

and whilst riding in a taxi. The subsequent plays unfolded out of the images and words of two people civilly sharing a late-night drink together or two other people talking about one other. But, Pinter claims, that process of unfolding plot and motivation is dictated wholly by the discovered characters, not the writer. That he professes to having the events of the play, and its conclusion, come into being in this manner, by simply listening to what his characters have to say and 'keeping his nose to the ground' is seemingly less credible than the simple notion that all of his plays grew from some initial germ of inspiration. He is nevertheless persistent in making this claim:

> Each time I write it is like opening the door to some unknown house. I don't know who is in the house. I don't know who is going to come in through the other door. I don't know what is going to happen. I never plan a play. One day I began to write *Ashes to Ashes*, and another day I knew it was complete.[2]

Despite this lack of planning, and the author's alleged ignorance of a play's outcome during the first stages of its being written, it is clear that a very disciplined conscious process has also been applied to the subconscious origins of each of his plays. The structurally neat construction of the plays and the economy of means that is employed in making them articulate are clear indications of this. Pinter, nevertheless, insistently distinguishes between the initial impulse that impels him to write and the need 'to organise that impulse and make it coherent' (*VV* 59).

The significance of this creative process is in the protective and nurturing stance taken with regard to the integrity of the initial inspiration. It is an artist acting not as the purveyor of easily digestible statements, but as the mediator of less than conscious impulses, of essential human truths. Pinter is unequivocally averse to any writer who 'puts forward his concern for you to embrace, who leaves you in no doubt of his worthiness, his usefulness, his altruism, who declares that his heart is in the right place, and ensures that it can be seen in full view, a pulsating mass where his characters ought to be' (*VV* 18). Bypassing both the bleeding heart and the calculating head, Pinter instead advocates writing as the funnelling of some uncontrollable, unpredictable, subliminal source.

Even Pinter's political plays fit within this equation. As has been demonstrated, they do not function to make specific statements about specific historic events or the behaviour of specific political regimes. Indeed, productions of them which earnestly do little other than attempt to 'preach to the converted' can often be empty experiences. Understanding their inspirational sources, and their subsequent tempering by the author's undeniable anger, unveils them as potent vehicles of revelatory outrage. *One for the Road*, for example, although inspired by Pinter's indignation at the apparent moral vacuity of certain Turkish guests at a reception he attended, was not written to decry those attitudes, but to explore their source. 'It wasn't the idea that started the play,' he explained, 'it was the image of the man that got it going' (*VV* 58). Nicolas, rather than Victor or Gila, is the interesting character, and the play essentially examines his being. All this arose from the image of a man at his desk, not an overriding need to condemn torture. As an artistic statement, *One for the Road* is of a piece with many of Pinter's non-political plays in that he presents an objective account of a given situation, to the point of permitting some empathy with Nicolas. 'I am just concerned with what people are, with accuracy',[3] Pinter once stated, and he seems to have been consistent in pursuing that aim.

Evidently, the chief goal of the artistic process defined here is to reproduce in some tangible form the responses to experience that are made by the artist's consciousness. But, in order to reproduce the essential truths that consciousness represents to the waking mind, there needs to be a process of artistic intervention. The conspiracy of firing neurones needs to be arrested and crafted into its most appropriate, communicative manifestation in palpable reality, a selection from and honing of the 'offered' material. Arguably, this is a function of consciousness anyway, in as much as it seems capable of visually articulating (in dreams, for example) the non-visual occupations of the waking mind. Perhaps such visual manifestations are the types of inspirational revelations that Pinter describes as initiating each of his plays: combinations of men and women in rooms, negotiating for superiority or struggling to appropriate memories. These certainly seem to represent examples of the 'efficient ideas' that the character of Pete in *The Dwarfs* seeks,

ideas that are purely communicative, and which allow for no undesirable symbolic resonances:

> Each idea must possess stringency and economy and the image, if you like, that expresses it must stand in exact correspondence and relation to the idea. Only then can you speak of utterance and only then can you speak of achievement. (*TD* 77)

It is tempting to read this as Pinter's earliest declaration of artistic intent, and Michael Billington explores it convincingly as such, drawing a parallel between Pinter's 'efficient idea' and T. S. Eliot's notion of the 'objective correlative'.[4] All the characters in the novel are often engaged in discussing the function and constitution of art and it is unlikely that Pinter was not expressing his own attitudes through them. He certainly applies judgements of efficiency and structural integrity to his works himself, stating, for example, of *Old Times* that 'there's no waste there.'[5] If we consider Pinter's plays as efficient ideas, inspired by momentary surges of revelatory experience and forged by the rigour of a disciplined wordsmith, we get closer to understanding how they operate upon us. The characters of these pieces, their combined responses, and the dramatic energies expended by the momentum of situations that ache to be resolved, all need to be considered, together, as standing 'in exact correspondence and relation to the idea'. It is this 'exact correspondence', this purity of means, that is a measure of Pinter's worth as a poet and a dramatist.

The communicability of Pinter's 'efficient ideas' is immediate, in that he strives to convey human experience directly, without excessive symbolism and without overly manipulating his discoveries to make any direct statements. Having found a manner in which he can articulate certain aspects of human interaction, he allows his artistic discoveries to resonate in each of us as subtle recognition, not tacit knowledge. Len in *The Dwarfs* is struck by the concrete communicability of music and describes Bach as having considered 'his music emanating through him and not from him. From A via Bach to C' (*TD* 44). This equates not only to Pinter's claimed writing process, but perhaps to the manner in which he hopes his writing might communicate. Later in the novel, having been to a concert performance of Beethoven's *Grosse Fuge*, Len declares: 'I've

never heard anything like it. It's not musical. It's physical. It's not music, it's someone sawing bones in a coffin' (*TD* 69). By rendering the effect of Beethoven upon Len in such neat visual and auditory terms, Pinter captures its infectious quality. This, surely, is the subtle recognition that theatre can offer. Perhaps Pinter's attraction to drama as a medium of expression lies in the fact that, unlike the novel, and much like music, it is an experiential art that might affect us through accumulation and pleasurable persuasion. Also like music, it can insinuate itself upon our emotions, and can bypass rational thought: 'I think theatre is about relish, passion, engagement' (*VV* 63) Pinter once commented.

Rebecca in the dim shade of her armchair, her words echoing around her; Deborah in her hospital bed; Ruth surrounded by adoring, needy men; Davies negotiating for forgiveness from the unyielding Aston; Stanley, voiceless in his new suit and broken glasses; all of these striking images are purely articulate. The combinations of these characters, in these environments, undergoing their specific fate act as living, breathing symbols of attitudes, moods and experiences that are buried within all of us and which are temporarily brought to the surface, tangibly recognizable, as we confront them on-stage in front of us. And yet they are symbolic, not in the sense that they convey one single facet of reality, or seek to express a unique point of view, but because they are irresistible. Peter Brook provides an apt definition:

> When we say 'symbolic' we often mean something drearily obscure: a true symbol is specific, it is the only form a certain truth can take [...] We get nowhere if we expect to be told what they mean, yet each one has a relation with us we can't deny.[6]

Here, Brook was speaking of Samuel Beckett's theatricality, but his words are equally applicable to Pinter's undeniable images. Combined with his unimpeachable control of language, and acute understanding of its latent energies, these images are amongst the most persuasive of the twentieth-century British stage. They come from the soul and touch us with precise sentiment and resounding fascination. They convey immediate impressions of existence, and serve to remind us of our humanity: the very joy, despair and passion of being.

Notes

INTRODUCTION

1. M. W. W., *Manchester Guardian*, 21 May 1958.
2. Harold Hobson, *Sunday Times*, 25 May 1958.
3. Martin Esslin, *The Theatre of the Absurd*, 3rd edn (London: Eyre Methuen, 1980).

CHAPTER 1. COMEDIES OF MENACE

1. Alan Pryce-Jones, *Observer*, 1 May 1960, 23.
2. Charles Marowitz, *Confessions of a Counterfeit Critic* (London: Eyre Methuen, 1973), 49.
3. Derek Granger, *Financial Times*, 20 May 1958.
4. A friend since their schooldays, Woolf was a postgraduate student at Bristol University in 1956 and wanted to present a new play at the recently established drama department there.
5. Martin Esslin, *The Theatre of the Absurd*, 3rd edn (London: Eyre Methuen, 1980), 400.
6. Esslin, *The Theatre of the Absurd*, 262.
7. Irving Wardle, 'Comedy of Menace', *The Encore Reader* (London: Eyre Methuen, 1965), 91. Wardle had borrowed the term from David Compton who had coined it to describe his short plays, collectively published in *The Lunatic View* in 1957.
8. Harold Pinter, in Mel Gussow, *Conversations with Harold Pinter* (London: Nick Hern Books, 1994), 36.
9. Peter Hall, *Making an Exibition of Myself* (London: Sinclair-Stephenson, 1993), 190.
10. Kullus appeared in three pieces of Pinter's writings: *Kullus* (1949), *The Task* (1954) and *The Examination* (1955).
11. Though discussed here, the radio version of *A Slight Ache* is not currently available in print. The page references are to the published stage version in *Plays One*.

12. Martin Esslin, *Pinter the Playwright* (London: Eyre Methuen, 1977), 92–3.
13. Simon Trussler, *The Plays of Harold Pinter, An Assessment* (London: Camelot Press, 1973), 64.
14. Harold Pinter, *Collected Screenplays 1* (London: Faber & Faber, 2000), 70.
15. Ronald Knowles, *Understanding Harold Pinter* (Columbia, SC: University of South Carolina Press, 1995), 88.
16. Katherine Burkman, *The Dramatic World of Harold Pinter: Its Basis in Ritual* (Columbus: Ohio State University Press, 1971), 101–2.
17. *A Night Out* was first presented on radio (BBC Third Programme on 1 March 1960) but was actually conceived as a TV drama.
18. Michael Billington, *The Life and Work of Harold Pinter* (London: Faber & Faber, 1996), 167.
19. Elizabeth Sakellaridou, *Pinter's Female Portraits, A Study of the Female Characters in the Plays of Harold Pinter* (London: Macmillan, 1988), 14–15.

CHAPTER 2. TRAGEDIES OF ISOLATION AND BELONGING

1. L. P. Hartley, *The Go-Between* (London: H. Hamilton, 1953), 1.
2. Pinter needed only to wait a year before the Theatres Act (1968) relieved the Lord Chamberlain, then Lord Cobbold, of his censorial duties.
3. Harold Pinter, 'Night School', *Plays: Two* (London: Eyre Methuen, 1979), 211. Though written for television, Faber & Faber publish the radio version of this play in *Plays Two*. The 1979 revision of the Methuen collection *Plays: Two* contained the original TV script and is quoted here.
4. Harold Pinter, 'Harold Pinter talks to Michael Dean', *Listener*, 6 March 1969, 312.
5. Harold Pinter, in Mel Gussow, *Conversations with Harold Pinter* (London: Nick Hern Books, 1994), 21.
6. Alan Hughes, 'They Can't Take That Away from Me: Myth and Memory in Pinter's *Old Times*', *Modern Drama*, xxvii (1974), 467–76.
7. Harold Pinter, in Gussow, *Conversations with Harold Pinter*, 38.
8. Martin Esslin, *Pinter The Playwright* (London: Eyre Methuen, 1977), 192.
9. Michael Billington, *Guardian*, 16 November 1978.
10. Katherine Burkman, 'Harold Pinter's *Betrayal*: Life Before Death – and After', *Theatre Journal*, 34 (1982), 515.
11. Released in 1983, the film starred Patricia Hodge, Jeremy Irons (Jerry) and Ben Kingsley (Robert).
12. *Family Voices* was first broadcast in January 1981, and later staged by Peter Hall at the National Theatre on 14 October 1982 as part of *Other Places*, a triple bill with *A Kind of Alaska* and the sketch *Victoria Station*.

CHAPTER 3. POLITICS AT PLAY

1. Harold Pinter, in Mel Gussow, *Conversations with Harold Pinter* (London: Nick Hern Books, 1994), 71.
2. Harold Pinter, 'Writing for Myself', *The Twentieth Century*, February 1961, 175. The article was reproduced as an introduction to *Plays Two*.
3. Marc Silverstein, 'One for the Road, Mountain Language and the Impasse of Politics', in *Modern Drama*, xxxiv, December 1991 (422–40), 426.
4. D. Keith Peacock, *Harold Pinter and the New British Theatre* (London and Westport, Connecticut: Greenwood Press, 1997), 143.
5. This is the crime of the blindfolded man about to undergo torture in *The New World Order* (P4 421).
6. Harold Pinter, in Gussow, *Conversations with Harold Pinter*, 152.
7. Harold Pinter to Eddie Mair, *Broadcasting House*, BBC Radio 4, 25 October 1998.
8. Harold Pinter, 'The Kurds have lifted their veil', *Guardian*, 20 February 1999.
9. Harold Pinter, 'Artists against the War', *Guardian*, 8 April 1999.
10. Harold Pinter, *Celebration and The Room* (London: Faber and Faber, 2000), 42.
11. Harold Pinter, *Celebration and The Room*, 49.
12. Harold Pinter, *Celebration and The Room*, 51.
13. Michael Billington, *The Life and Work of Harold Pinter* (London: Faber & Faber, 1996), 293.
14. Ronald Knowles, *Understanding Harold Pinter* (Columbia, SC: University of South Carolina Press, 1995), 189.
15. Harold Pinter to Jean-Louis Perrier, in *Le Monde*, 15 October 1997. My translation. The article to which Pinter refers is 'It Never Happened', (*VV* 197–9).
16. Harold Pinter to Nick Hern, in *One for the Road* (London: Eyre Methuen, 1985), 11.

CHAPTER 4. EFFICIENT IDEAS

1. Harold Pinter, 'Writing for Myself', *The Twentieth Century*, February 1961, 72. The article was reproduced as an introduction to *Plays Two*.
2. Harold Pinter to Jean-Louis Perrier, in *Le Monde*, 15 October 1997. My translation.
3. Harold Pinter, in *Isis*, 1 February 1964, 19.
4. Michael Billington, *The Life and Work of Harold Pinter* (London: Faber & Faber, 1996), 63.
5. Harold Pinter, in Mel Gussow, *Conversations with Harold Pinter* (London: Nick Hern Books, 1994), 21.
6. Peter Brook, *The Empty Space* (London: Penguin, 1968), 64–5.

Select Bibliography

This book has attempted to consider each of Pinter's works in terms of the themes they project and how they might operate theatrically, divorced from their historical context or the incidents in their author's life that might have inspired or informed him. Michael Billington's biography and D. Keith Peacock's study might ideally serve to complement this book in this respect.

WORKS BY HAROLD PINTER

With the exception of the 2000 play *Celebration*, Pinter's entire output for radio, TV and the stage is available in the four play collections published by Faber & Faber. The recent expanded editions of *Plays Three* and *Plays Four* differ slightly in content from their previous editions to permit the incorporation of *Moonlight* and *Ashes to Ashes*. *Various Voices: Poetry, Prose and Politics 1948–1998*, makes suitable complementary reading to the dramatic works.

Celebration and The Room (London: Faber & Faber, 2000).
Collected Screenplays 1 (London: Faber & Faber, 2000).
Collected Screenplays 2 (London: Faber & Faber, 2001).
Collected Screenplays 3 (London: Faber & Faber, 2001).
The Dwarfs (London: Faber & Faber, 1990).
Plays One: The Birthday Party, The Room, The Dumb Waiter, A Slight Ache, The Hothouse, A Night Out, The Black and White (short story), *The Examination* (London: Faber & Faber, 1991).
Plays Two: The Caretaker, The Dwarfs, The Collection, The Lover, Night School, Trouble in the Works, The Black and White, Request Stop, Last to Go, Special Offer (London: Faber & Faber, 1996).
Plays Three: The Homecoming, Tea Party, The Basement, Landscape, Silence, Night, That's Your Trouble, That's All, Applicant, Interview, Dialogue for Three, Tea Party (short story), *Old Times, No Man's Land* (London: Faber & Faber, 1997).

Plays Four: Betrayal, Monologue, One for the Road, Mountain Language, Family Voices, A Kind of Alaska, Victoria Station, Precisely, The New World Order, Party Time, Moonlight, Ashes to Ashes (London: Faber & Faber, 1998).
Poems and Prose, 1949–1977 (London: Eyre Methuen, 1978).
The Proust Screenplay (London: Eyre Methuen, 1978).
The Trial (London: Faber & Faber, 1993).
Various Voices: Poetry, Prose and Politics 1948–1998 (London: Faber & Faber, 1998)

CRITICISM AND BIOGRAPHY

Almansi, Guido, and Simon Henderson, *Harold Pinter* (London: Methuen, 1983). A useful survey of Pinter's use of game-playing.

Baker, William, and Stephen Ely Tabachnick, *Harold Pinter* (Edinburgh: Oliver & Boyd, 1973). An examination of Pinter's plays up to *Old Times*, with a specific emphasis on conflict between the sexes. There is also some useful biographical material.

Billington, Michael, *The Life and Work of Harold Pinter* (London: Faber, 1996). An essential companion to any study of Pinter's achievement. Billington provides analyses of the dramatist's writings and key biographical data, and contextualizes one within the other.

Bold, Alan (ed.), *Harold Pinter: You Never Heard Such Silence* (London: Vision Press, 1984). A small collection of essays, including various analyses of Pinter's symbolism and an insightful look at directing Pinter by Peter Hall.

Burkman, Katherine H., *The Dramatic World of Harold Pinter: Its Basis in Ritual* (Columbus, OH: University of Ohio Press, 1971). An interesting survey of the structures of rituals that are apparent in Pinter's works.

—— and John L. Kundert-Gibbs (eds.), *Pinter at Sixty* (Bloomington and Indianapolis: Indiana University Press, 1993). A collection of academic essays, with useful material on the screenplays and the political plays.

Cahn, Victor L., *Gender and Power in the Plays of Harold Pinter* (Houndmills: Macmillan, 1994). An analysis of the gender issues that arise in specific plays.

Dukore, Bernard, *Harold Pinter* (London and New York: Macmillan, 1982). A useful survey.

Esslin, Martin, *Pinter the Playwright* (4th edn; London: Methuen, 1982). A renamed, expanded and updated version of *The Peopled Wounded: The Plays of Harold Pinter* (1970) and *Pinter: A Study of His Plays* (1973). A very readable and accessible survey of Pinter's plays and use of language. For terse synopses of plots and themes, this is a good place to start.

———— *The Theatre of the Absurd* (3rd edn; London: Penguin, 1980). Contains a good chapter analysing Pinter's early dramas in terms of their apparent absurdism.

Gale, Steven H., *Butter's Going Up: A Critical Analysis of Harold Pinter's Work* (Durham, NC: Duke University Press, 1977). A valuable appraisal of Pinter's work.

———— (ed.), *Harold Pinter: Critical Approaches* (London: Associated University Presses, 1986). A strong collection of essays on a variety of subjects, including Pinter's screenplay adaptations and work for radio.

———— (ed.), *Critical Essays on Harold Pinter* (Boston: G. K. Hall, 1990). Another good collection of diverse essays.

Gordon, Lois (ed.), *Harold Pinter: A Casebook* (New York: Garland, 1990). A useful students' guide.

Gussow, Mel, *Conversations with Pinter* (London: Nick Hern Books, 1994). An interesting and revealing collection of transcribed interviews with our usually reticent dramatist.

Hayman, Ronald, *Harold Pinter* (London: Heinemann, 1973). An introductory survey of Pinter's early plays.

Kerr, Walter, *Harold Pinter* (New York: Columbia University Press, 1967). An enlightening approach to Pinter's expression of existential concerns.

Klein, Joanne, *Making Pictures: The Pinter Screenplays* (Columbus, OH: State University Press, 1985). A thorough appraisal of Pinter's achievements in adapting novels for the screen.

Knowles, Ronald, *Understanding Harold Pinter* (Columbia, SC: University of South Carolina, 1995). An academic survey of Pinter's plays and screenplays, treating selected plays in depth.

Merritt, Susan Hollis, *Pinter in Play: Critical Strategies and the Plays of Harold Pinter* (Durham and London: Duke University Press, 1990). A survey of reading of Pinter filtered through major critical schools of thought.

Page, Malcolm (ed.), *File on Pinter* (London: Methuen, 1993). A valuable collection which marries play synopses with associated press articles, reviews and snippets of interviews.

Peacock, D. Keith, *Harold Pinter and the New British Theatre* (London and Westport, CT: Greenwood Press, 1997). An excellent survey of Pinter's writings, with the plays located firmly in their social and cultural contexts and the theatrical traditions from which they grew.

Regal, Martin, *Harold Pinter: A Question of Timing* (London: Macmillan, 1994). Regal appraises Pinter's manipulation of time, and offers comment on the influence of Joyce and Proust.

Sakellaridou, Elizabeth, *Pinter's Female Portraits* (London: Macmillan, 1988). A valuable study which considers the changing representa-

tion of woman in Pinter's work.

Scott, Michael, (ed.), *Harold Pinter: The Birthday Party, The Caretaker & The Homecoming* (London: Macmillan Educational, 1986). A useful casebook of study materials.

Strunk, Volker, *Harold Pinter: Towards a Poetics of His Plays* (New York: Lang, 1989). An analysis of Pinter's distinctive style.

Taylor, John Russell, *Anger and After* (Harmondsworth: Penguin, 1963). A good chapter on Pinter's plays up to and including *The Homecoming*, examining their theatrical style and Pinter's approach to realism.

Thompson, David T., *Pinter, the Player's Playwright* (London and New York: Macmillan, 1985). A detailed study of Pinter's early career as an actor, and the possible subsequent influence on him as a writer.

Trussler, Simon, *The Plays of Harold Pinter: An Assessment*, (London: Victor Gollancz, 1973). A candid appraisal of the strengths and weaknesses of Pinter's early plays, finishing with *Old Times*.

Index